LEGENDAR

OF

BROOKLINE

MASSACHUSETTS

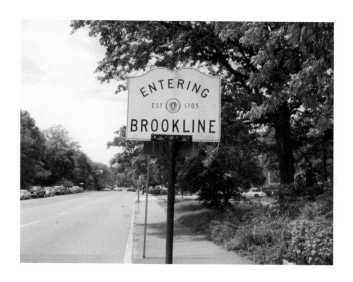

Farmers' Market

Thursday afternoons in the summertime it is not uncommon to see Brookline residents toting canvas bags filled to capacity with fresh carrots, bell peppers, and just-picked bouquets. From June to October in Coolidge Corner in the Centre Street parking lot, more than a dozen farms and artisanal food purveyors gather to sell their products, rain or shine. In 2012, the Brookline Winter Farmers' Market debuted in the Arcade Building on Harvard Street. (Courtesy of Becca Cahan.)

Page 1: Entering Brookline Sign

Longtime Brookline resident and photographer Jean Stringham took a series of photographs of the town, including this welcome sign. In 2007, she and her husband, Peter, traveled to Brookline's sister city, Quezalguaque, Nicaragua, as members of All Saint's Episcopal Parish's weeklong mission project to refurbish the back yard of the local library and create a flower garden. In 2013, the Brookline Commission for the Arts selected Jean Stringham's color photographs for a Brookline Town Hall Walls exhibit. The exhibit ran from November 2013 to January 2014. (Courtesy of Jean Stringham.)

LEGENDARY LOCALS
OF

BROOKLINE
MASSACHUSETTS

JENNIFER CAMPANIOLO

LEGENDARY
LOCALS

Dedication
To Michael, with love.

On the Front Cover: Clockwise from top left:
John Hodgman (courtesy of John Hodgman; see page 27), Frederick Law Olmsted (courtesy of the Frederick Law Olmsted National Historic Site; see page 109), Jill Medvedow (photograph by Asia Kepka; see page 111), Rishi Reddi (courtesy of P.J. Tannenbaum; see page 39), Reed Kay (courtesy of Ben Aronson; see page 118), John F. Kennedy (courtesy of the Library of Congress; see page 70), Osvaldo Golijov (courtesy of Tanit Sakakini; see page 56), Michael Dukakis (courtesy of the Library of Congress; see page 77), Cristina Powell (courtesy of Leanne Powell; see page 116).

On the Back Cover: From left to right:
Dana Brigham (photograph by Bruno Giust; see page 12), Charles Sprague Sargent (courtesy of the Library of Congress; see page 93).

CONTENTS

Acknowledgments 6

Introduction 7

CHAPTER ONE Business 9

CHAPTER TWO Entertainment 23

CHAPTER THREE Literature 31

CHAPTER FOUR Music 51

CHAPTER FIVE Politics and Social Good 65

CHAPTER SIX Science, Medicine, and Law 89

CHAPTER SEVEN Visual Arts 105

Index 127

ACKNOWLEDGMENTS

I would like to thank the following people for providing suggestions of individuals to profile, images, quotes, and other materials for this book: R. Harvey Bravman of Advanced Digital Websites and publisher of BrooklineHub.com, town historian Larry Ruttman, Ken Liss of the Brookline Historical Society, and Gary K. Wolf.

I would also like to thank my editors at Arcadia Publishing: Erin Vosgien, for having the faith in me that I could write this book and for her patience and gentle guidance throughout the project, and Kris McDonagh, for guiding me back on track.

INTRODUCTION

Within Brookline's 6.8 square miles of elegant brownstones, million-dollar mansions, and two-family houses live 58,732 people. Young, single urban professionals commute on the Green Line of the T alongside senior citizens who live here because of its excellent reputation as a retirement destination. Families with small children move here for the quality schools—unlike nearby Boston, Brookline's student population is exploding—a problem to be sure, but also an indication that you are doing something right. Among the many synagogues are popular Unitarian, Protestant, and Catholic churches. Brookline has a successful small business community that manages to thrive among the chain stores, thanks in part to the efforts of the merchants association and Brookline Local First. Brookline Booksmith, which just celebrated its 50th anniversary, may be one of the few independent bookstores in the country to essentially drive a major chain out of business after Barnes & Noble shuttered its Brookline location in 2008. Clear Flour Bread, founded in 1982, boasts long lines of customers who prefer its fresh baguettes to the local bakery chain's.

When you think of Brookline, the words "rich" and "liberal" likely spring to mind. At least that's how many outsiders perceive the town—in a recent ranking of the snobbiest small cities in America by Movoto Real Estate Blog, Brookline came in at No. 3, after Palo Alto, California, and Bethesda, Maryland. While it is true that Brookline is a wealthy town, and voter turnout for the last major election in 2012 was almost 70 percent (with four to one voting for Barack Obama over former Massachusetts governor and Republican Mitt Romney), there is much more about Brookline that sets it apart from other towns in the commonwealth.

In fact, from its very beginnings as a hamlet of Boston, Brookline stood apart, first geographically and then by the will of its people, who resisted being annexed by Boston. There is no doubt that the city that surrounds Brookline holds some sway, but in general that has proved to be a good thing. Brookline's residents benefit from the many universities, museums, concert halls, and hospitals that are just a few subway stops away. Many of the students and musicians and doctors and scientists who make up these Boston institutions opt to make Brookline their home during off hours. Again, Brookline benefits.

When I say that Brookline stood apart geographically, I am referring to the lay of the land when the town was first settled in the early 17th century. Brookline, or Muddy River as it was named because of the river that demarcated the southeast frontier separating the hamlet from Boston, was not always so accessible. According to *A History of Brookline, Massachusetts, From the First Settlement of Muddy River Until the Present* (1906), to reach Brookline from Boston, you had to follow a serpentine path; it was a detour of about four miles and involved going around Back Bay and the head of the river, then following the line of what is now Washington Street, through Roxbury Street to Roxbury Crossing, and then by Tremont Street and Huntington Avenue to the bridge at Brookline Village. Consequently, in 1633, a Boston court announced: "It was agreed that there shall be a sufficient cart bridge made in some convenient place over Muddy River."

At that time Muddy River counted about 40 families, and even when the town was made independent in 1705, the number stayed relatively the same at 50 families. In *Brookline: A Favored Town* (1897), author Charles Knowles Bolton wrote, "The number did not increase materially until near the beginning of the next century when the country-house population began to be a feature of Brookline."

Records are unclear on how the town got its name, but both *A History of Brookline, Massachusetts* and *Brookline* cite the name of Judge Samuel Sewall's farm, called Brookline, because of its location on the boundary of Muddy River and Boston.

The interesting difference between Brookline and many other Massachusetts towns is that, while other towns like Lowell and Framingham depended on manufacturing to boost their economies,

Brookline had very little manufacturing. It also did not have large corporations headquartered within its boundaries. What made Brookline a desirable place to live then—as now—was its central location and its natural beauty. Residents brought their wealth with them, and the town was the beneficiary.

Today, it is not just wealth that makes Brookline special—after all, there are plenty of other wealthy towns in America that are less distinctive. The people of Brookline are what make this town unique. A Russian bazaar and a popular Thai restaurant are just doors down from each other. A block of Jewish businesses hums on Sundays while a convenience store owned by an immigrant Spanish family offers wine tastings on Saturdays. In Brookline, urban diversity meets suburban living. By day, the town is bustling and alive, and by night, most residential streets are as quiet as the country—the ban on overnight parking may sometimes frustrate, but there is something to be said for minimizing car traffic at night.

When choosing the subjects for this book, I was struck by the many choices that lay before me. Of course, there were the famous locals who everyone has heard of, but when I started to dig deeper, I discovered lots of fascinating artists, entertainers, humanitarians, and writers. There were two famous writers living on my block alone! Working on this book has produced in me a sort of secondary pride— pride that I live in this town among such legendary locals and that I have the opportunity to benefit from their talent and experience.

I hope this book captures the variety and uniqueness of Brookline and its denizens, then and now: local heroes like Jim Solomon, the owner of The Fireplace Restaurant, who spearheaded a town-wide effort to encourage all restaurants to "green" their businesses; artists like husband-and-wife team Alejandro and Moira Siña of Siña Lightworks, whose amazing work with colored lights is well-loved in the community; and local teens like Sarah Gladstone, who, at the ripe old age of 12, started a charity selling bracelets to raise money for women in third-world countries suffering from obstetric fistulas. The book will also include the famous faces in Brookline history, from John F. Kennedy to John Hodgeman, and the local celebrities like Ethel Weiss, owner of Irving Toy and Card Shop, which has been operating since 1939, and Seth Barrett, owner of the new and popular handyman hangout, Village Green Renewal LLC.

Siña Lightworks
This is a Siña Lightworks installation at 1501 Beacon Street. (Courtesy of Alejandro Siña.)

CHAPTER ONE

Business

Being a walkable city not only benefits the residents of Brookline—it is also a boon for its business owners. From Coolidge Corner to Brookline Village to Washington Square, Brookline boasts a thriving downtown shopping scene. The Green Line on the T takes shoppers up and down Beacon Street, and a crosstown bus shuttles passengers to shops on Harvard Street. In this chapter, there are businesspersons who love plying their trade in this town, like legendary local Rosaline Lowe, who owned Rosaline's Skincare and Spa at 1426 Beacon Street for 25 years. The aesthetician has very warm feelings about Brookline and her supportive clientele. Lowe, who is originally from Grenada, said that even as a new business owner she was pleased with her choice of location. "I felt very welcome here and although I was asked several times if I had ever experienced any racial discrimination, I can honestly say I haven't."

Then there is restaurateur Jim Solomon, owner of The Fireplace Restaurant in Washington Square. The site for his restaurant is just blocks from his childhood home. Solomon is active in local charities and takes pride in the fact that The Fireplace is a Certified Green Restaurant. Since 1990, the Green Restaurant Association (GRA) has been providing convenient and cost effective ways for businesses and consumers to become more environmentally responsible. As a Certified Green Restaurant, The Fireplace does not use polystyrene foam ("Styrofoam") and has a full-scale recycling program. Recently, Solomon made the surprise announcement that he will be closing The Fireplace as of December 31, 2014, to focus on his booming catering business. He has publicly challenged other area restaurants to join him in going green.

One of Brookline's legendary locals who successfully steered her business through the choppy waters of changing times is Dana Brigham. The Brookline Booksmith turned 53 this year, due in large part to the efforts of Brigham and her staff, who cater to the community in a way that mega-stores do not. "Surviving is the new thriving," Brigham told WBUR.org during an interview about the liquidation of the Borders Group in 2011. Although selling print books in the digital age has become a tenuous business, Brigham credits the community for helping to keep her store popular. She also cites the "curated, distilled selection of books" they choose to carry. Of course the Booksmith has made changes to remain relevant in the 21st century; it has an online store where it sells, among other things, Kobo ebooks.

Brookline residents can support the number and variety of independent businesses in their neighborhood by making an effort to shop local whenever possible. Legendary local Mai Le Libman is leading the charge with her mobile app Savione. Libman created Savione to help connect customers with small local businesses. The free app provides users with a map and icons that show where different stores are located and the products that are available at each shop. The information contained in Savione comes from a crowdsourced database. The app is interactive; customers and merchants can upload pictures of products and product information that is then added to the store's page. Libman, who describes Savione as "a virtual mall of local indie stores," started working on the prototype in 2011. Her aim is to help small businesses level the playing field when competing against online behemoths like Amazon—and the big box stores, many of which are a car ride away.

Several of the legendary locals in this chapter—Dana Brigham, Chobee Hoy, and Jim Solomon—belong to Brookline Local First. The BLF was formed in March 2012 with the mission "to build a

strong local economy and vibrant community by educating residents and local government leaders about the significant environmental, economic, and cultural benefits of doing business with locally-owned, independent businesses." Local businesses can apply to join the BLF; participating shops identify themselves with the BLF sticker on their front door.

Legendary local R. Harvey Bravman knows all about the importance of shopping local—he is on the steering committee of Brookline Local First and is the former president of the Coolidge Corner Merchants Association. When area chain Panera Bread put a "shop local" sticker on its door, Bravman was not impressed. As publisher of the independent community website Brookline Hub, he took to his computer and wrote a passionate editorial about the true meaning of the "shop local" sticker:

> I take it they [Panera Bread] want us to assume they are local, but the reality is if we were to really take the sticker's advice, we would get our bread at Clear Flour Bread instead. Abe and Christy [Faber] own Clear Flour, you can go into their bakery and ask for them by name about 12+ hours out of every day, because they always seem to be there. There is no way Abe or Christy can accurately tell you off the top of their head how many local causes they support, but sometimes it appears that it's all of them. What about Panera Bread? Panera is headquartered in St. Louis, not Brookline. They have 1,673 company owned and franchise locations operating in 44 states and Ontario with approximately 3.5 billion in annual revenue. So what is Panera's "shop local" sticker all about?

When asked about his experience as a business owner in Brookline, Bravman said, "What I love most about Brookline is the commitment of its residents and shopkeepers. The people of Brookline have inspired me to want to make a difference. You can't say much more about a community than that."

Without question, one of the town's most dedicated shopkeepers is Ethel Weiss. In fact, no book on legendary locals of Brookline would be complete without mention of Weiss and her little shop with the candy-striped awning, Irving's Cards and Toys. In August 2013, Ethel celebrated her 99th birthday in a public way—at a party right outside the store she has run for the last 75 years. And the public came—generations of customers who consider Weiss to be like a grandmother. Although shop hours are more limited these days, Weiss always tries to be open when the nearby Devotion School classes let out. At that time, a line of grade school kids naturally forms outside Irving's door. When asked by *Brookline Tab* reporter Ignacio LaGuarda what the best part of her job is, Weiss answered, "Seeing a little two-year-old come into the store with a quarter to buy a lollipop." She never plans to retire, she said, because there is no one she could trust to run the place the way she has. So she keeps showing up . . . just like her customers.

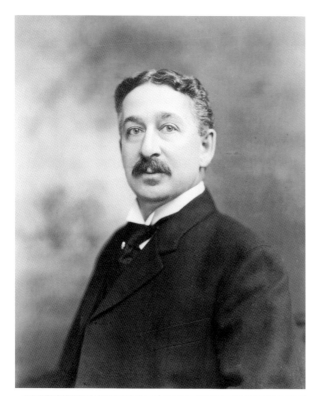

King Gillette (1855–1932)
King Camp Gillette was a young traveling salesman who improved on the products he sold, registering four patents. But it was his disposable-blade safety razor that would become his legacy. Frustrated with sharpening the blade on his Star Safety Razor, Gillette teamed up with a Massachusetts Institute of Technology engineer, William Emery Nickerson, to develop a razor with a blade that could be discarded. They founded the American Safety Razor Company in 1901. (Courtesy of the Library of Congress.)

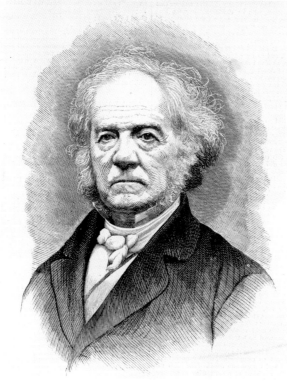

Lewis Tappan (1788–1873)
Lewis Tappan lived in Brookline from 1816 to 1830, marrying Susanna Aspinwall in 1813. His legacy is in the credit reporting business— somewhat ironic for the strict Calvinist who believed in paying cash. As a businessman, he realized that accepting credit meant making a sale. So he started keeping records of his customer's creditworthiness. This practice became a business when other merchants came to Tappan for information on their customers' credit histories. (Courtesy of the Library of Congress.)

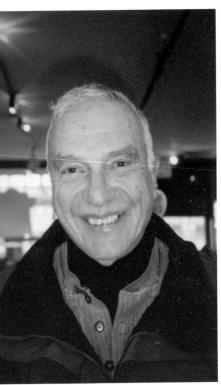

Marshall Smith
Brookline High School graduate Marshall Smith is the founder and majority owner of the Brookline Booksmith. Smith opened what was then the Paperback Booksmith in 1961 with the slogan "Dedicated to the fine art of browsing." He was one of the first booksellers to arrange books by category rather than by publisher, making it easier for shoppers to find what they were seeking. (Photograph by Larry Ruttman.)

Dana Brigham
Dana Brigham is the store manager and co-owner of the Brookline Booksmith. The beloved bookstore has been a fixture in Coolidge Corner for over 50 years. Brigham reflected, "My favorite part of managing the store for 32 years is watching our booksellers arrive as novices, grow and learn here, and then leave us for wonderful careers in publishing, writing, libraries, teaching, journalism. Being an incubator of sorts is extremely rewarding." (Photograph by Bruno Giust.)

Ilene Bezahler

Ilene Bezahler is the founder, editor, and publisher of *Edible Boston*, a free, quarterly locavore food magazine. After leaving the corporate world post-9/11, Bezahler joined Allandale Farm, the last working farm in Brookline. She learned the value of sustainable agriculture to local communities. "I began publishing *Edible Boston* in the summer of 2006," Bezahler said. "It was just the beginning of the local food movement and there was a lot of skepticism about whether it would succeed. Seven years later, the movement has become well established and the magazine is successful. The most important thing that I have gotten out of the experience is that it has helped change people's lives. Our mission is to tell the stories of our local farmers, bakers, butchers and brew masters [and] entice readers to come out and buy from the producers." (Courtesy of *Edible Boston*.)

Elias Audy
Elias Audy owns and operates two Mobil service stations and the used car dealership Cypress Automart. He is the President of the AABA (American Arab Benevolent Association) and is on the board of the Brookline Education Foundation. Audy is the recipient of numerous community awards and has served as president of the Rotary Club and the chamber of commerce. He came to the United States from Lebanon at age 19 to study and, later, followed his older brother Bill into the gas business. Elias is married to Laurde, also from Lebanon, and they live in West Roxbury next door to Bill and his family. (Elias and Bill's wives are also sisters.) Attorney Roger Lipson told the *Boston Globe*, "When you think of the phrase 'pillar of the community,' Audy is the kind of man you're talking about." (Courtesy of Zana Audy.)

Rosaline Lowe
Originally from Grenada in the Caribbean, Brookline resident Rosaline Lowe is an esthetician with her own skincare line and the author of *Skinversity: A Guide to Treating All Skin Types* (2013). For 25 years, she was the owner of Rosaline's Skincare and Spa at 1426 Beacon Street. Looking to start a new chapter in her life, Lowe recently shuttered her physical location and now focuses on her online skincare business. (Photograph by Mark Manne.)

Mai Le Libman
Brookline's Mai Le Libman is the creator of Savione, an app that helps connect customers with small local businesses. The free app has a map and icons that show a store's location and products that are available. Libman told the *Brookline Tab*, "A lot of people don't equate their spending with supporting local. We want people to know that you can actually find really great items in these local shops." (Courtesy of Margaret Lampert Photography.)

Jim Solomon

In 1987, James Solomon, chef and owner of the award-winning The Fireplace restaurant, quit a fast-paced career on Wall Street to pursue his passion for cooking. Solomon is as well known for his charitable contributions as he is for New England cuisine. He volunteers for Seeds of Peace, a summer program that teaches Middle Eastern teens how to promote unity in their communities. Solomon is also involved in the Brookline Go Greener campaign and helps the Brookline Emergency Food Pantry by volunteering at the annual Food Festival. Solomon's altruism may stem in part from his own experiences with adversity.

In 1992, Solomon was hit by a car and sustained massive injuries. It would be nearly a decade before he would open The Fireplace, located in Brookline just blocks from his childhood home, but it would prove worth the wait. (Courtesy of The Fireplace.)

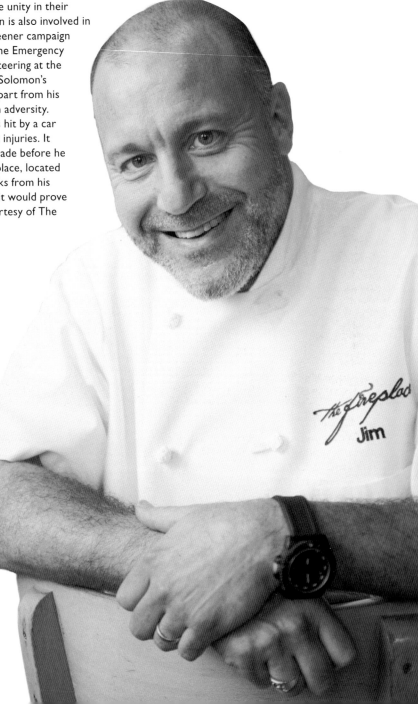

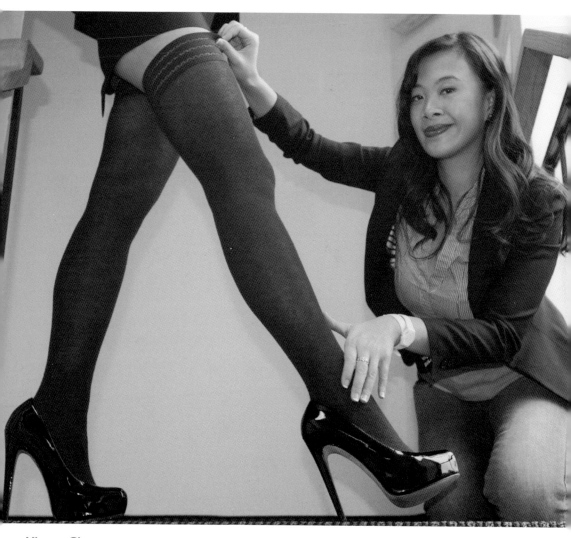

Vienne Cheung

Vienne Cheung, a graduate of Pierce School and Brookline High School, is the owner of the Brookline-based luxury hosiery company VienneMilano. While still in her twenties, Cheung earned her master's of business administration and landed a plum corporate job. But in 2011, when she turned 30, she decided to leave the cubicle farm behind and start her own business. VienneMilano's thigh highs are made in Milan, Italy, hence the name. Her elegant yet comfortable hosiery comes in different colors, textures, and patterns—from sheer to argyle to fishnet—and all feature sturdy silicone thigh bands to keep them in place, even without a garter belt. In 2013, models at a couture event at New York Fashion Week strutted down the runway wearing lavish gowns paired with VienneMilano thigh highs. (Courtesy of Ted Ancher, the *Boston Herald*.)

Lydia Shire
Lydia Shire is a James Beard Award–winning chef and restaurateur whose career has spanned nearly four decades. The Brookline native is the creator of Scampo in Boston's Liberty Hotel. Shire said, "I don't see any barriers for women [chefs] out there now. There are tons of women cooking. While the balance is not quite equal yet—there are more male chefs, no question about it—women have made long strides." (Photograph by Larry Ruttman.)

Fran Berger
As of this writing, Fran Berger is the chairman of the board of the Brookline Chamber of Commerce. She is the founder and principal for WriteAway Communications, which she started after a 25-year career in radio management. She has been a citizen advocate on cable television for more than 20 years. She received her bachelor's of science from Boston University and her master's from Harvard University. (Courtesy of Fran Berger.)

Chobee Hoy

Chobee Hoy, who was named after Lake Okeechobee in Central Florida, moved to Brookline in 1960 when her husband got a job at Boston University. Chobee has always been committed to volunteerism. When she was raising her three children, she also volunteered at Boston State Hospital, which, at the time, served the mentally ill. That led to a salaried position at the hospital as a director of volunteers. Other volunteer positions—with a caterer and the Girl Scouts—also led to job offers. In 1980, Hoy got her real estate license, and after several years working for others, she opened her own business, Chobee Hoy Associates, in 1990. She continues to do volunteer work, helping the Coolidge Corner Theatre Foundation, the Brookline Arts Center, the annual Artists Open Studio Tour, the Brookline High School 21st-century Fund, and others. She also chairs the steering committee of Brookline Local First. (Photograph by Larry Ruttman.)

R. Harvey Bravman

Harvey Bravman is the owner of Advanced Digital Websites and the publisher of BrooklineHub.com, an independent, nonprofit news website. He is the founder of FeedBrookline, a yearly initiative to raise money for the Brookline Emergency Food Pantry, and the Annual Brookline Youth Awards, which honor teenaged humanitarians. Harvey is scheduled to produce a documentary for the Town of Brookline on residents who survived the Holocaust. (Courtesy of R. Harvey Bravman.)

Seth Barrett

Seth Barrett is the owner of Village Green Renewal LLC in Brookline Village, which also serves as an artisans' collaborative space, where custom fabricators, woodworkers, and builders meet. Barrett is the quintessential New Englander: practical, resourceful, and a bit on the quiet side. When going by his shop, look through the front window to see firsthand how his focused concentration speaks volumes about his passion for restoration work. Also pictured here is Claire Locuwood. (Courtesy of Gwen Ossenfort.)

Barbara Yona Soifer

Barbara Yona Soifer's neighbors dubbed her "the mayor of Washington Square" because of her tireless devotion to the neighborhood. She was born in Belgium after World War II to a Polish mother and Ukrainian father who had both escaped persecution in their native countries during the Holocaust. When she was five, the family moved to Brookline. Barbara worked alongside her father—grudgingly at first—at his watchmaking and repair business. After her parents' deaths, she decided to take up the business at the Little Swiss House. She also became immersed in the local merchants' association and created the annual First Light Festival to encourage people to do their holiday shopping locally. She was involved in the erection of the Washington Square Victorian clock and the flower-planting project, Washington Square Green Thumbs. She died of cancer in 2009. (Photograph by Larry Ruttman.)

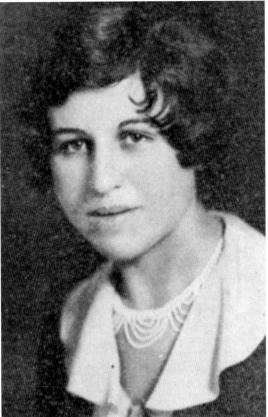

Ethel Weiss

Ethel Weiss is the owner of Irving's Toy and Card Shop, which, in 2014, celebrated 75 years of serving neighborhood families. Weiss has been called "Brookline's Guardian Angel," "a Legend," and "an Institution." The students of nearby Devotion School line up every day to get their sugar fix from Weiss, who is like "everyone's grandmother." Weiss and her husband, the late Irving Kravetz, opened Irving's in 1939. After his death, Weiss continued to run the shop. Today, it appears that little has changed in the tiny store with the red-striped awning. Weiss uses an old-fashioned cash register, only accepts cash, and still places her orders by phone. Weiss's daughter, Anita Jamieson, told a reporter, "She was a busy mother. I suppose she was a little bit ahead of her time, because she was very much interested in having a career." (Courtesy of Ethel Weiss.)

CHAPTER TWO

Entertainment

The legendary locals in this chapter include an actress, a television news reporter, a comedian, and the creator of a quirky money tracking game favored by numbers geeks.

There are also some famous names of people who, while not pictured in this book, are sure to sound familiar to anyone over the age of, say, 40. In fact, if you were a teenager in the late 1980s or early 1990s, no matter if you were at the mall, the beach, or the dentist's office, you couldn't avoid the harmonized vocals of five boys from Boston beseeching "Please Don't Go Girl"—New Kids on The Block (or NKOTB as they were also known). The youngest (and arguably the cutest) of the R&B boy band singers was Joey McIntyre. McIntyre was the youngest member of the group, selected by manager Maurice Starr because he reminded him of a young Michael Jackson. After the band broke up in 1994, McIntyre pursued acting, starring on Broadway and in the television series *Boston Public*. Although he's not originally from Brookline (McIntyre was born in Needham and grew up in Jamaica Plain), he lived here after hitting it big with the band. An Irish Catholic born into a family of nine children, McIntyre has been married to real estate agent Barrett Williams since 2003; they have three children.

In the 1980s *The Cosby Show* was must-see TV, breaking the sitcom mold by featuring an upper-middle-class African American family and paving the way for shows like *Modern Family*. And—particularly in the first few seasons—it was a very funny show. Michelle Thomas (1968–1998) was best known for playing Justine, Theo Huxtable's girlfriend, on the show. Thomas was born in Brookline and grew up in Montclair, New Jersey. Her father, musician Dennis "D.T." Thomas, is a founding member of the R&B group Kool & the Gang, and her mother, Phynjuar Thomas, is an actress who appeared with her daughter in the 1990s sitcom *Family Matters*. Phynjuar described to *People* magazine her daughter's off-screen romance with her *Cosby Show* co-star, Malcolm Jamal-Warner, "Malcolm was the love of her life. I think he was her only real boyfriend." Although the couple broke up in 1994, they remained friends. At age 27, Michelle was diagnosed with intra-abdominal Desmoplastic Small Round Cell Tumor, a rare malignancy typically found in young males. She died at the age of 30.

When the question of famous people who hail from Brookline comes up, John F. Kennedy is inevitably the first name out of people's mouths. The second? Conan O'Brien. The boyish talk show host has one thing in common with the 35th president of the United States: they were both born here. Actually they have two things in common—both are Harvard University grads. But then their paths diverge.

"Like a lot of you, I wasn't sure where I fit into high school," O'Brien said in 2003 as he recalled his Brookline High days in front of a packed auditorium at his alma mater. "I wasn't a good athlete, I sucked in math, I wasn't very good in science. In a lot of ways I was an insecure person when I went to Brookline High School." Note to today's class of BHS students: that insecure kid ended up replacing David Letterman on *Late Night*.

Brookline boasts a connection to several television news reporters, all with very distinct styles and points-of-view. As a child, Barbara Walters briefly attended school in Brookline—Walters is a former student of the Lawrence School. Once dubbed the "Today Girl" because of her 11-year run on NBC's *The Today Show*, Walters retired from television journalism in May 2013 with a legacy of awards, coveted interviews with world leaders and celebrities, and the achievement of being the first woman co-anchor of a network evening news program. Although that gig only lasted two years (and inspired *Saturday*

Night Live comedian Gilda Radner's famous parody, "Baba Wawa"), it would lead to Walters's legendary prime-time specials in which she practiced her signature "probing-yet-casual" interviewing style, which often caused her subjects to respond with uncharacteristic candor. Her famous interviewees include Anwar Sadat of Egypt, former presidents Richard Nixon and Jimmy Carter, Margaret Thatcher, the Dalai Lama, Moammar Ghadafi, and Fidel Castro. Her 1996 interview with former White House intern Monica Lewinsky was the highest-rated news program ever broadcast on a single network. In 1997, she debuted her mid-morning talk show *The View*, which she continues to executive produce. She once revealed one of her interviewing secrets: "Wait for those unguarded moments. Relax the mood and, like the child dropping off to sleep, the subject often reveals his truest self."

The late Mike Wallace (1918–2012) graduated from Brookline High School, class of 1935. Friend Morley Safer called his *60 Minutes* colleague "the toughest guy on television." Known for his confrontational style when interviewing controversial public figures—from Malcolm X to Roger Clemens (Wallace's final interview before his death)—the former radio and TV announcer was born in Brookline. He served in the US Navy during World War II. Although Wallace sometimes came across as cocky, he secretly struggled with depression. Wallace won 21 Emmy Awards; his favorite *60 Minutes* interview was with piano virtuoso Vladmir Horowitz in 1977. In an interview with Safer near the end of his life, Wallace said, "It's astonishing what you learn and feel and see along the way . . . that's why a reporter's job is such a joy."

David Susskind, considered one of the first television talk show hosts, grew up here. Born in New York City and raised in Brookline, Susskind (1920–1987) was one of the earliest and best-known TV talk show hosts as well as a Broadway and Emmy Award–winning television producer. In a career that spanned 40 years, he hosted two talk shows. In 1958 there was *Open End*, a show with no air time limit—the host and his guests talked on a subject until they were spent. Less cutting-edge perhaps, but more successful, was the *The David Susskind Show*, which debuted in 1967 and ran for nearly 30 years. Susskind's views about television changed over time—early in his career, he referred to show business as "the most dynamic and interesting field I could get into." Toward the end of his career, however, *The New York Times* quoted Susskind as saying, "I thought television could be much more of an illuminating beacon—informing, instructing, educating, taking the public by the hand and leading it. But American television was never that. I was a younger and more idealistic David Susskind. I am not a cynic today. I am simply pragmatic."

Former Brookline resident Liz Walker, the first woman of color to host the Boston evening news, is still actively involved in the community. In January 2014, the former WBZ news anchor appeared at the Martin Luther King Jr. remembrance ceremony at the Coolidge Corner Theatre to give the keynote. She now lives in Jamaica Plain, but as she addressed the crowd at the ceremony, she said, "Even though I moved recently, my heart is always here."

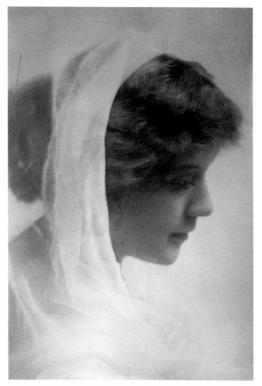

Ida Conquest (1867–1937)
Ida Conquest was a turn-of-the-century
theater actress. The daughter of a Boston
merchant, she made her dramatic debut as
Buttercup in the Boston Museum Company's
production of *H.M.S. Pinafore*. Her professional
career was launched in 1892 and continued
until 1910—she appeared in *Too Much Johnson*,
The Tyranny of Tears, and *Man and Superman*.
She married a director of a jewelry company
and spent her later years designing jewelry.
(Courtesy of the Library of Congress.)

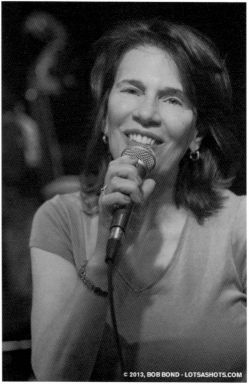

Hildy Grossman
Hildy Grossman is a clinical psychologist and
professional singer. She is cofounder of the
jazz/cabaret act *The Follen Angels* and the
founder and artistic director for Upstage Lung
Cancer, a nonprofit that uses musical theater
to raise money for research. A survivor herself,
Grossman says, "Instead of focusing on 'What
if?' I want to put my considerable energy into
our original *Ziegfeld!* show. We won't stop until
we upstage lung cancer!" (Courtesy of Bob
Bond, Lotsa Shots.)

© 2013, BOB BOND · LOTSASHOTS.COM

Shawn LaCount
Shawn LaCount is a founder and artistic director of Company One Theatre in Boston. LaCount told the *Brookline Tab* that Company One's mission is "to shine a spotlight on underserved voices." After graduating from Clark University in Worcester, LaCount and five other Clark graduates formed a touring production and, later, Company One. Their mission was "to change the face of Boston theater by uniting the city's diverse communities through innovative, socially provocative performance and developing civically engaged artists." Since 1998, they have produced and staged over 50 plays. They also offer educational outreach programs, reaching over 10,000 students. They were awarded the Mass Cultural Counsel's Gold Star Award, which recognizes exemplary cultural programs funded by local cultural councils that celebrate diversity, foster collaboration, showcase artistic excellence, and provide learning experiences for people of all ages and backgrounds. (Courtesy of Shawn LaCount.)

John Hodgman

John Hodgman is an author and comedian with a signature droll delivery and nerdy persona. He is the author of the *New York Times* bestsellers *The Areas of My Expertise* (2005) and *More Information Than You Require* (2008). He is perhaps best known for his appearances on the Comedy Central news satire *The Daily Show with Jon Stewart*, which began as a guest spot and morphed into a recurring gig. He is also familiar to television viewers as the guy who played the "personal computer" alongside actor Justin Long in a series of popular Apple commercials; ironically, Hodgman is a Mac user. He has also guest-starred in the HBO comedy series *Bored to Death* and starred in *Ragnarok*, a Netflix original comedy special. (Courtesy of John Hodgman.)

Patrick Gabridge
Patrick Gabridge is a playwright, novelist, and local farmer. He helped start Boston's Rhombus Playwrights Writer's Group and has penned plays for the Huntington Theatre Company and the New Rep in Watertown. He and his wife started the Pen and Pepper Farm in Dracut, Massachusetts, in 2012. Gabridge's creativity is partially inspired by his neighbors. He said, "I love how there are so many creative and smart people in our neighborhood—It's easy to end up talking at the playground to another parent who is also a writer, or a painter, or a filmmaker, or who runs a theater company." (Courtesy of Patrick Gabridge.)

Hank Eskin
Hank Eskin is the creator and webmaster of Where's George?, a website that tracks the circulation of American paper money. Users, who call themselves "Georgers," log onto the site, enter their bill's serial number and their home zip code, then stamp the bills with the Where's George? URL, and spend them. When someone else sees the bill with the URL on it, they can enter the bill's information again, which triggers an email, or "hit," to the original Georger. According to NPR.org, "part of the attraction for users is the math and data." Eskin started the website in 1998; since then, over 200 million bills have been tracked. A theoretical physicist at Northwest University even started using data from Where's George? to test theories about networks, model the H1N1 flu epidemic, and map the flow of currency in the United States. (Courtesy of Amie Littman.)

Joe Zina

Joe Zina served as the executive director of the Coolidge Corner Theatre from 1999 to 2009. He is largely credited with the rebirth of the 1933 landmark from a doddering art house to a successful, nationally and internationally recognized cultural gem. In his decade at the helm, he led three successful capital campaigns and directed the renovation of the theater. Earlier in his life, Zina traveled the world as a professional dancer. In the 1980s, he and his partner, Bernard Toale, founded a paper company, Rugg Road Paper and Prints. Reflecting on his time at the Coolidge Corner Theatre, Zina modestly told the *Boston Globe*, "I picked up a paintbrush and a scraper and painted the walls and scraped the gum off the bottom of the seats and floor and tried to make it a better place." (Photograph by Larry Ruttman.)

CHAPTER THREE

Literature

What is it about Brookline that attracts so many writers? It would be possible to dedicate a whole volume of *Legendary Locals of Brookline* just to local authors. Perhaps the reason can be found in the surrounding city. Boston's many universities are brimming with students who feel passionate about the written word, whether they are writing their own poetry or reading someone else's.

Although famous writers in history like Nathaniel Hawthorne, Ralph Waldo Emerson, and Henry Wadsworth Longfellow belong to other Massachusetts towns, Brookline can boast poet Amy Lowell, who was born in 1874 at Sevenels, a 10-acre estate here. Lowell was a modernist poet with a wide circle of famous friends like Robert Frost, D.H. Lawrence, and Thomas Hardy (and sometimes friends-turned-enemies, like Ezra Pound, who believed Lowell appropriated Imagism from him). Amy Lowell's older brother, Abbott Lawrence Lowell, was the president of Harvard University, and her younger brother, Percival Lowell, was an astronomer who founded Lowell Observatory in Flagstaff, Arizona. Amy Lowell would enjoy success as well, although her biggest prize—the Pulitzer Prize for Poetry in 1926—would happen after her death.

Amy Lowell is not the only legendary local who is a prize-winning poet. More recently, David Ferry won the National Book Award for his collection *Bewilderment: New Poems and Translations*. Speaking to Patricia Cohen of the *New York Times* after winning another prestigious prize, the $100,000 Ruth Lilly Poetry Prize for lifetime achievement, Ferry said "he was thrilled with the award, and described himself as writing about people who are displaced in life and confused 'like myself.' " Ferry was born in New Jersey but later moved to Brookline.

Then there are legendary locals Derek Walcott and Saul Bellow. Walcott, a poet and playwright, is a native of St. Lucia in the Caribbean but lived in Brookline when he won the Noble Prize for Literature in 1992. A new collection of his life's work has just been published, *The Poetry of Derek Walcott, 1948–2013* (2014). Saul Bellow was a multiple winner of top literary prizes, including a Noble, a Pulitzer, and a National Book Award. He died in Brookline in 2005; upon his death, writers as varied as Clive James, Allegra Goodman, and Dave Eggers wrote loving tributes to the novelist and playwright on Slate.com, all describing his influence on their writing.

Brookline loves a good paperback mystery—the Brookline Library hosts the popular Mystery Book Discussion Group every third Tuesday of the month. There are so many local mystery and thriller novelists that the New England Chapter of Mystery Writers of America sees fit to have its monthly meetings at the Brookline Library as well. In this chapter are mystery writer Linda Barnes and a new Brookline legendary local, bestselling writer Dennis Lehane, author of *Mystic River* (2001) and *Live By Night* (2013). Lehane was born in Dorchester and only recently moved to Brookline with his family. In addition to writing thriller novels, Lehane has been busy with his new publishing imprint, Dennis Lehane Books, as well as earning screenwriting credits for the HBO series *Boardwalk Empire*.

Speaking of the big screen, when the Coolidge Corner Theatre did a special screening of the 1988 part-animation/part-live action film *Who Framed Roger Rabbit?* recently, it was rush line seats only. Some of the audience members may have wondered if a certain Brookline resident was among them—the creator of the character Roger Rabbit, Gary K. Wolf. A short essay Wolf wrote about one of his proudest moments as a writer is featured with his picture in this chapter; the picture is actually the cover from his most recent Roger Rabbit mystery, *Who Wacked Roger Rabbit?* published in 2013.

In the genre of nonfiction writing, there is also no shortage of talent in Brookline. Susan Senator, who has written two nonfiction titles about autism and one novel, started her writing career as a bimonthly columnist for the *Brookline Tab*. Now, she writes for WBUR's ideas and opinions website Cognoscenti. Pulitzer Prize–winning writer Ellen Goodman is also a legendary local. In 2007, Goodman confronted one of this country's last conversational taboos: death. She formed the Conversation Project, an initiative to get people talking to each other about their end-of-life wishes before it is too late.

People look to nonfiction writers, like Eve LaPlante and Larry Ruttman, to not only chronicle the past but to also make sense of it. They often pay attention to the small details of life that elude the rest of us. LaPlante is the author of several nonfiction books featuring history-makers like Anne Hutchinson, Samuel Sewall, and Louisa May Alcott. The surprise is when one discovers that there are blood ties between LaPlante and her subjects, making her biographies even more intimate. Larry Ruttman is Brookline's oral historian. The author of *Voices of Brookline* (2005) and *American Jews and America's Game: Voices of a Growing Legacy in Baseball* (2013) is a master at getting people to talk about themselves (a skill that has earned him friends all over town) and then transcribing those stories with skill and good humor.

In one of those interviews featured in *Voices of Brookline*, Ruttman talks to legendary local Sarah Smith, a mystery writer and huge fan of William Shakespeare; she even wrote a book about the enigmatic bard, *Chasing Shakespeares* (2003). In the interview, Smith gave the following answer to the question that opened this chapter: why do so many writers make Brookline their home?

> We have one of the nation's best bookstores, she said, the Brookline Booksmith, which was named Bookstore of the Year by the American Booksellers Association a couple of years ago. Dana Brigham and the staff at Brookline Booksmith are wonderful people, and very good at supporting writers. And then there's the Brookline library, which I use for a lot of my research. The present-day Brookline Library has a long shelf of material relating to Shakespeare; the stacks have more material than some college libraries.

Amy Lowell (1874–1925)

Amy Lowell was born at Sevenels, a 10-acre estate in Brookline. The Lowells were a wealthy and well-connected Boston family that included a future president of Harvard University (Amy's older brother, Abbott Lawrence) and an astronomer (another brother, Percival). The precocious little sister who once walled herself up in her family's 7,000-book library so she could study literature, did not start writing professionally until she was in her thirties; her first poem, "Fixed Idea," was published in a 1910 issue of the *Atlantic Monthly*. She went on to publish her first collection, *A Dome of Many-Coloured Glass,* in 1912. She wrote a biography on one of her literary heroes, 19th-century poet John Keats, and started a movement to popularize Imagist poetry in America. Her poetry collection *What's O' Clock?* was published posthumously and won the Pulitzer Prize for Poetry in 1926. (Courtesy of Houghton Library, Harvard University.)

Louise Andrews Kent (1886–1969)

Author Louise Andrews Kent was born and raised in Brookline. She graduated from Simmons College School of Library Science in 1909 and, three years later, married Ira Rich Kent, with whom she had three children. She wrote children's books like *The Brookline Trunk*, which traces the history of Muddy River back to the 1630s, and a series of New England–themed cookbooks under the homespun guise of "Mrs. Appleyard."

In 1955, *Kirkus Reviews* said of *The Brookline Trunk*: "While the flavor is distinctly regional, the humor and the universal values extend its fascination far beyond children of the Eastern seaboard." (Courtesy of the Vermont Historical Society.)

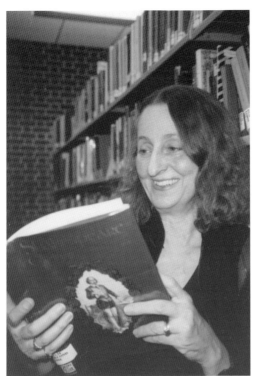

Sarah Smith

Sarah Smith, a Brookline resident, is a mystery writer. She is the author of three historical novels: *The Vanished Child* (1997), *The Knowledge of Water* (1997), and *A Citizen of the Country* (2000), as well as a young adult mystery, *The Other Side of Dark*, which won the Agatha Award for Best Children's/Young Adult Novel. Sarah has a bachelor's of arts and a doctorate in English literature from Harvard University. (Photograph by Larry Ruttman.)

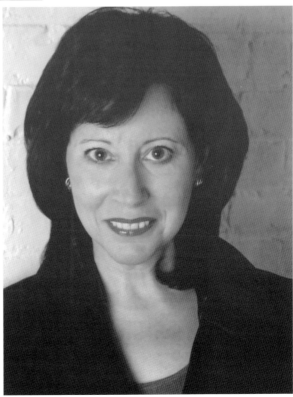

Linda Barnes

Linda Barnes is a mystery writer and the creator of the Carlotta Carlyle series. She first introduced the redheaded private detective/ Bostonian in 1985, in her Anthony Award–winning short story "Lucky Penny." Since then, she has written 12 Carlotta Carlyle mysteries, the most recent being *Lie Down with the Devil* (2008), which was named by *Publishers Weekly* as one of the best mysteries of that year. (Courtesy of Lynn Wayne/ St. Martin's Press.)

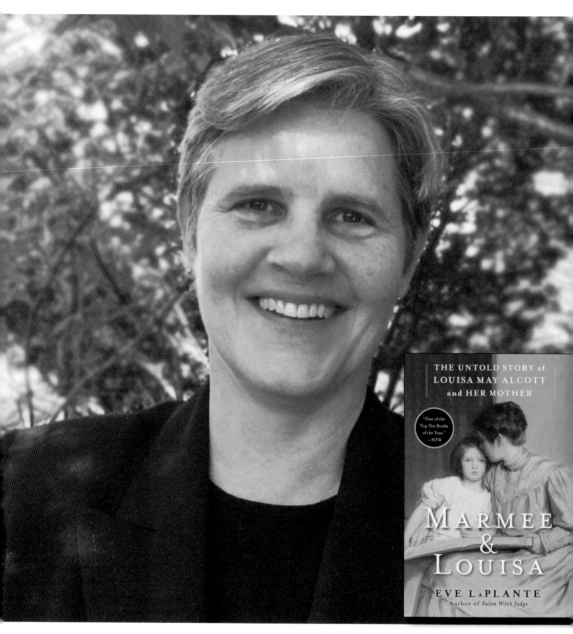

THE UNTOLD STORY of
LOUISA MAY ALCOTT
and HER MOTHER

"One of the
Top Ten Books
of the Year."
—NPR

MARMEE
&
LOUISA

EVE LaPLANTE
Author of *Salem Witch Judge*

Eve LaPlante

Brookline resident Eve LaPlante likes to keep her writing "all in the family." LaPlante is the author of five nonfiction books, almost all of which feature her New England ancestors as her subjects. There is *American Jezebel* (HarperOne, 2004), which is about a colonial heretic and LaPlante's distant relative, Anne Hutchinson, and *Salem Witch Judge* (HarperOne, 2007), which is about Samuel Sewall—the judge whose supreme act of contrition after the controversial Salem witch trials was to become an abolitionist and feminist. LaPlante's most recent biography, *Marmee & Louisa* (Free Press, 2012), is about LaPlante's cousin Louisa May Alcott and her great-niece Abigail May Alcott. Time will tell if any of LaPlante's four children will take up the pen and be the next generation to document their fascinating family history. (Courtesy of David F. Dorfman; inset, courtesy of Free Press.)

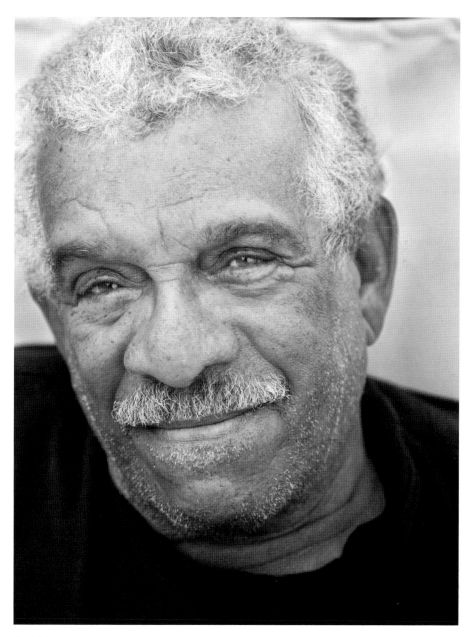

Derek Walcott
Although Derek Walcott is of West Indian descent, he was a Brookline local when he won the Nobel Prize in Literature in 1992—the first Caribbean writer to win this most prestigious honor. The poet and playwright won the award for a "poetic oeuvre of great luminosity, sustained by a historical vision, the outcome of a multicultural commitment." Walcott published his first poem, "1944," in his local newspaper *The Voice of St. Lucia* at 14, and by 19 he had self-published two poetry collections: *25 Poems* (1948) and *Epitaph for the Young: XII Cantos* (1949). Walcott received a MacArthur Foundation Genius Award, a Royal Society of Literature Award, and the Queen's Medal for Poetry. He also won an Obie Award in 1971 for his play *Dream on Monkey Mountain*. In 1981, he founded the Boston Playwrights' Theatre. (Courtesy of Danielle Devaux.)

David Ferry
David Ferry is a poet and translator and winner of the 2012 National Book Award. Born in Orange, New Jersey, Ferry was not a bookish child but learned to appreciate writing and literature while at Amherst College, where he earned his undergraduate degree in 1948—an education interrupted by Ferry's service in the Air Force. While getting his graduate degree at Harvard University, Ferry had his first poem accepted in the *Kenyon Review*. He is the Sophie Chantal Hart Professor Emeritus of English at Wellesley College, a distinguished visiting scholar at Suffolk University, and a visiting lecturer at Boston University. Writing about Ferry's poetry in the *New York Times Book Review,* Carmeal Ciruaru said, "His speakers are not at home in life; they are always on the outside looking in—to their own minds, their bodies, the places they call home." (Courtesy of Stephen Ferry/Matrix.)

Rishi Reddi

Rishi Reddi was born in Hyderabad, India, the capital and largest city of the southern Indian state of Andhra Pradesh. Growing up, she lived in various parts of Great Britain and the United States, earning her undergraduate degree at Swarthmore College and her law degree at Northeastern University School of Law. She balances her writing with her work as an environmental lawyer for state and federal governments. Her first collection of short stories, *Karma and Other Stories* (Ecco, 2007) was the winner of the 2008 PEN New England/L.L. Winship prize for fiction. The title story from that collection was chosen for the 2013 Boston Book Festival's One City One Story program. Her next project, a novel set in California's Imperial Valley in the 1920s, is forthcoming. (Courtesy of P.J. Tannenbaum; inset, courtesy of Rishi Reddi.)

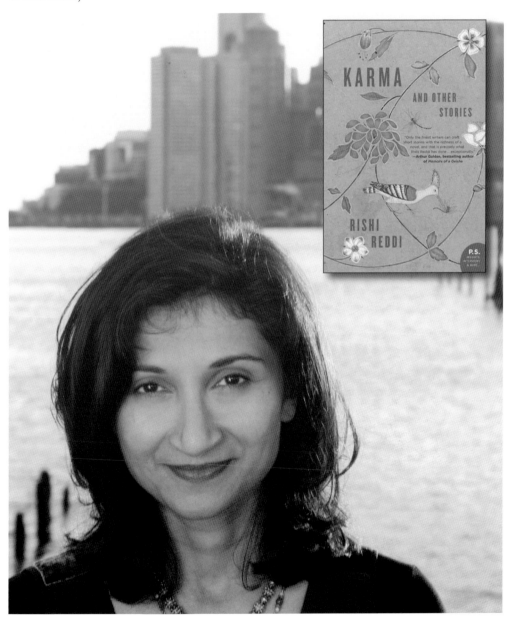

Dennis Lehane

Dennis Lehane has been called "a crime writer's crime writer" (*Daily Mail*) and "one of Hollywood's most powerful authors" (*Hollywood Reporter*). Hyperbole this is not. Lehane, who is originally from Dorchester but who lived in Brookline in 2013, is the author of nine gritty novels, including three that were turned into Hollywood movies: *Shutter Island*; *Gone, Baby, Gone*; and *Mystic River*. His latest novel, *Live by Night*, won the 2013 Edgar Award for Best Novel. When Lehane is not penning novels, he is writing for television; he wrote three episodes of the Emmy Award–winning HBO series *The Wire* and is a creative consultant for another HBO drama, *Boardwalk Empire*. He is the editor of his own imprint with Harper Collins Publishers, Dennis Lehane Books. (Courtesy of Ashleigh-Faye Beland.)

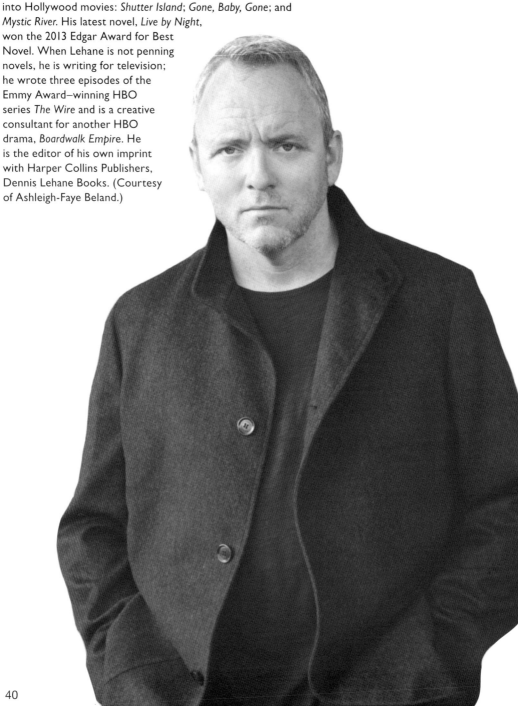

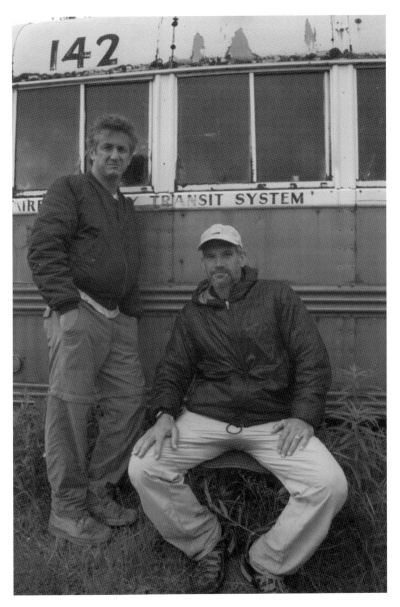

Jon Krakauer

Jon Krakauer was born in Brookline and raised in Corvallis, Oregon. He started mountaineering when he was eight years old and reached his climbing peak when he scaled Mount Everest in 1996. That infamous climb was documented in an article for *Outside* magazine, winning a National Magazine Award, and in a bestselling book, *Into Thin Air* (1999). Krakauer is also the author of *Into the Wild* (1997), *Under the Banner of Heaven* (2003), and *Where Men Win Glory* (2009). In 2011, Krakauer wrote an expose for the site Byliner.com about bestselling author and humanitarian Greg Mortenson. In *Three Cups of Deceit*, Krakauer delved into lies and fabrications in Mortenson's bestseller *Three Cups of Tea* and alleged that Mortenson misappropriated funds from his charity, Pennies for Peace. Krakauer donated all his proceeds from sales of *Three Cups of Deceit* to charity.

Jon Krakauer, at right, is pictured with the director of *Into the Wild,* Sean Penn. (Photograph by and courtesy of Roman Dial.)

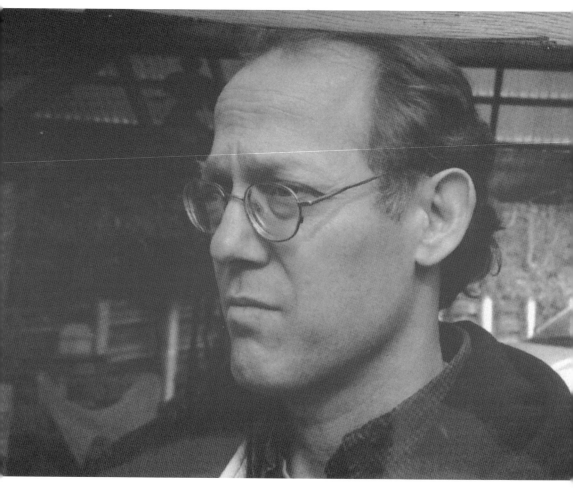

Alan Shapiro
Poet Alan Shapiro grew up in Brookline. He told the *Carolina Quarterly*: "In 1965, in a bookstore in my hometown, in the late afternoon of an ordinary school day, in the middle of winter, I discovered my inner Beat poet." That young writer went on to publish 10 poetry collections. He was invited to the White House when Bill Clinton was president to read his work; he chose a poem about Michael Jordan winning a basketball championship—the poem was called "On Men Weeping." Shapiro has taught at Stanford University and currently teaches English at the University of North Carolina at Chapel Hill. (Courtesy of Alan Shapiro.)

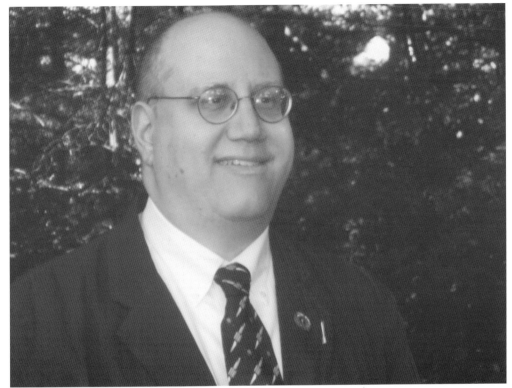

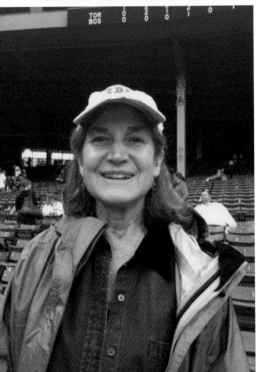

Michael A. Burstein

Michael A. Burstein is a science fiction writer whose first successful foray into publishing was a short story published in *Analog* magazine in 1995, the Hugo-nominated "TeleAbsence." He is the winner of the 1997 Campbell Award for Best New Writer. His most recent collection is *I Remember the Future* (Apex Publications, 2008). He and his wife, Nomi, write a parenting column together. They live in Brookline with their twin daughters. (Courtesy of Nomi S. Burstein.)

Judith Steinbergh

Judith Steinbergh is a poet, teacher, and scholar. She served as Brookline's first Poet Laureate for two years, when she created several poetry initiatives, including A World of Poetry in Brookline, which had readings of poems in languages other than English, and the Poetry Brookline Project, where people of all ages post poems about Brookline. Steinbergh is the author of *Marshmallow Worlds*, with Cary Wolinsky; *Motherwriter*; *A Living Anytime*; and *Writing My Will*. (Courtesy of Judith Steinbergh.)

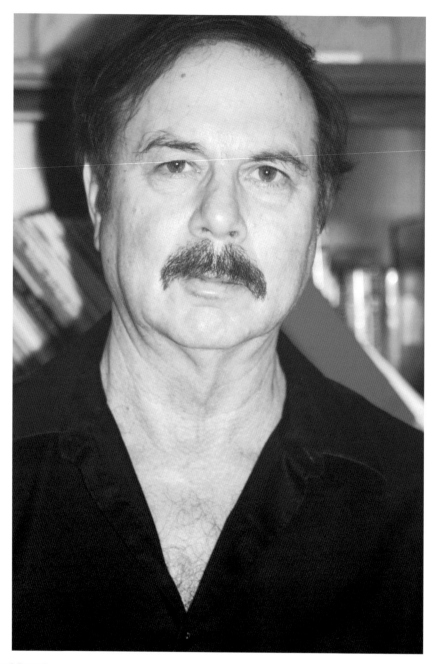

Richard Burgin
Author Richard Burgin's 16th work of fiction, *Hide Island: A Novella and Ten Stories* (Texas Review Press, 2013) is populated by a motley cast of characters—from doctors and drug dealers to businessmen and prostitutes. On the website The Daily Beast, literary luminary Joyce Carol Oates praised Burgin: "What Edgar Allan Poe did for the psychotic soul, Richard Burgin does for the deeply neurotic who pass among us disguised as so seemingly 'normal' we may mistake them for ourselves." Burgin—who was born in Brookline—is also known as the founding and current editor of the nationally acclaimed literary magazine *Boulevard*, publishing short stories and poetry since 1985. (Courtesy of Richard Burgin.)

Stanley Cavell
Stanley Cavell is a philosopher, teacher, and the author of 18 books, including the memoir *Little Did I Know* (2010). He is the Walter M. Cabot Professor of Aesthetics and the General Theory of Value Emeritus at Harvard University. Born in Atlanta, Cavell studied music at the University of California, Berkeley, and was accepted into Juilliard, but he gave up music to pursue a degree in philosophy. He lives with his wife in Brookline. (Courtesy of Vivienne Penglase.)

Larry Ruttman
Larry Ruttman is an attorney, an author, and an oral historian. The lifelong Brookline native is the author of *Voices of Brookline* (2005); it contains written transcriptions of taped interviews Ruttman conducted with Brookline residents. His latest book is *American Jews and America's Game* (2013). The Korean War veteran has been married to his wife, Lois, for 50 years. He was recently elected as a Fellow of the Massachusetts Historical Society. (Courtesy of Larry Ruttman.)

Susan Senator

In her *New York Times* essay "The Subject of the Sibling," Susan Senator describes reading her son Max's college application essay. Max writes about his older brother, Nate, who is profoundly autistic. Max has learned to "broaden his definition of normal" and has accepted his brother's limitations. In her writing about the developmental disease, Senator has helped others also broaden their definition of normal. A former columnist for the *Brookline Tab*, Susan Senator's books include *Making Peace with Autism*, *The Autism Mom's Survival Guide (For Dads, Too!)*, as well as the novel *Dirt*. She is an award-winning blogger on autism spectrum disorders. On her website, susansenator.com, she shares why she became a writer: "Through my essays, articles, and books I am trying to make sense of Autism . . . and help others with this challenge of Autism at the same time." (Courtesy of Susan Senator.)

Susan Quinn
A biographer, playwright, and journalist, Susan Quinn has had a long and storied writing career. First publishing under a pseudonym (Susan Jacobs) in 1967 for the book *On Stage* (Knopf), she later published her second book, *A Mind of Her Own: The Life of Karen Horney* (Summit Books, 1987) under her given name. That book won the *Boston Globe*'s Laurence L. Winship Award. Another biography, *Marie Curie: A Life* (Simon & Schuster, 1995) followed and won Quinn both a Guggenheim Fellowship and a Rockefeller Foundation Writing Residency at Bellagio in Italy. Her most recent book, *Furious Improvisation* (Walker & Company, 2008) got a starred review from *Library Journal*, which called Quinn's narrative about FDR's Federal Theatre Program "both fascinating and frightening." (Courtesy of Barry Goldstein.)

Ellen Goodman

Ellen Goodman is a Pulitzer Prize—winning writer, speaker, and commentator. She is the author of *Paper Trail: Common Sense in Uncommon Times* (Simon & Schuster, 2007) and coauthor with her best friend, novelist Patricia O'Brien, of *I Know Just What You Mean: The Power of Friendship in Women's Lives* (Touchstone, 2001.) Goodman is also a columnist for the political website truthdig. Her latest effort, an organization dedicated to helping people talk about their wishes for end-of-life care called the Conversation Project, hits close to home for the social advocate. When her own mother was in the last years of her life, Goodman had to make many of her end-of-life decisions for her. "I realized only after her death how much easier it would have all been if I heard her voice in my ear as these decisions had to be made." (Courtesy of Ellen Goodman.)

David Schmahmann

David Schmahmann was born and raised in Durban, South Africa. He moved around for school and work, living in India, Israel, Burma, and the United States. His first novel, *Empire Settings* (White Wine Press, 2001), received the John Gardner Fiction Book Award. The *Richmond Times-Dispatch* described reading Schmahmann's *The Double Life of Alfred Buber* (Permanent Press, 2011) as being "a little like stepping onto a theme-park ride designed by a well-read madman." Interviewed by the *Jewish Advocate*, Schmahmann explains how his writing "is very informed by my Orthodox Jewish education and my sense of discomfort growing up in South Africa as a Jew." He is very happy to live in America; as he told the *Advocate*, "I think being an immigrant adds an edge to my appreciation. I don't take for granted that what we cherish in America is immutable." (Photograph by Larry Ruttman.)

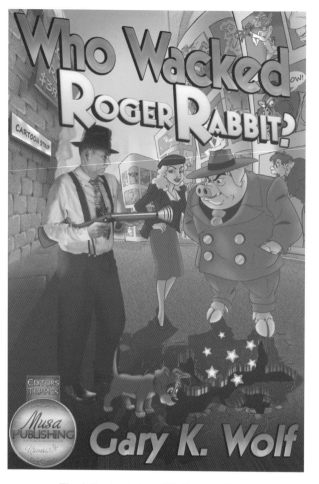

Gary K. Wolf

Gary K. Wolf is best known as the creator of Roger Rabbit, the animated star of the Academy Award–winning movie *Who Framed Roger Rabbit?* Released in 1988, the film's worldwide gross was close to $134 million. It was based on Wolf's 1982 fantasy-noir novel *Who Censored Roger Rabbit?* An author, screenwriter, lecturer, and entertainment consultant, Wolf has lived in Brookline since 1981. He met his wife while they were both doing their laundry at a Laundromat just off Corey Road. Wolf spent his childhood like most boys—reading comic books. Eventually, he became interested in noir mysteries and science fiction. He has written 10 novels including the first new Roger Rabbit mystery in 22 years, 2013's *Who Wacked Roger Rabbit?*

The following is from Wolf's essay "Running Through Brookline with Roger Rabbit:"

A reporter for the *Boston Globe* wanted to do an interview with me.

We met at one of my favorite breakfast places, the old B&D Deli on Beacon Street. (Like a Pavlovian running dog, I always got an intense craving for a bagel when I ran by the B&D during each of the sixteen times I did the Boston Marathon.)

For the photo, I brought with me a life-sized Roger Rabbit doll.

The hostess graciously seated us at a table for three.

The reporter started the interview by sound checking her tape recorder. "I'm here today with Gary K. Wolf, the creator of Roger Rabbit," she said. Then, to make sure the recorder was working, she played her intro back. At full volume. Her words reverberated through the entire deli.

All talking ceased.

Somebody started to clap. Others joined in. Pretty soon everybody was applauding.

A little girl got up from her table, came over to me, and asked if I would autograph her napkin. Pretty soon I had a line of autograph seekers snaking through the tables.

That was the first time I had ever gotten public acclaim for anything I had written.

I'll never forget that moment, nor the restaurant full of Brookliners who made my day.

(Courtesy of Musa Publishing.)

CHAPTER FOUR

Music

In 2006, when Brookline local legend Johanna Hill Simpson stepped down as the artistic director of PALS Children's Chorus, the *Boston Globe* classical music critic at the time, Richard Deyer, wrote, "From the beginning, PALS demonstrated that 'ordinary' school children—not exceptionally gifted musicians trained in a performing arts school—could reach an extraordinary artistic standard. It is sad to think that any children, anywhere, would be capable of this if our culture pursued different priorities and if there were enough Jody Simpsons to go around." This opinion of the talent and dedication of one of the nation's most preeminent children's conductors is shared by many who know Jody—one of the legendary locals of Brookline featured in this chapter.

Indeed Brookline has a strong tradition of nurturing its youngest musicians. The PALS Children's Chorus (the acronym stands for "Performing Artists at Lincoln School") and programs offered through the nonprofit Brookline Music School, for example, exist to foster a lifelong love of music in the town's youngest residents.

PALS Children's Chorus is an independent, non-profit organization in residence at the W.H. Lincoln School in Brookline. PALS serves all seven Brookline K-8 schools, as well as other public and private schools in the Boston area. It is committed to diversity, with a need-blind admission policy and approximately 150 choristers from a variety of socioeconomic, religious, cultural, and racial backgrounds. The children of PALS have collaborated with the Boston Symphony Orchestra, Boston Pops, Cantata Singers, Back Bay Chorale, Boston Philharmonic, and others to make beautiful music together. Ideally, these early experiences will help shape their passion for music for the rest of their lives.

Founded in 1924, the Brookline Music School is the oldest and largest cultural institution in town. In 2014, the BMS celebrated its 90th year of operation. The school was originally founded to "enhance the Brookline Public School orchestras by providing music lessons to the children of Brookline after hours on school premises." Towards that aim, the Brookline Public Schools donate classroom space to Brookline Music School for private music lessons. The Brookline School of Music also offers summer arts programs with music, dance, and art activities for kids. Of course, people of all ages love and appreciate music: the faculty at the school can often be heard playing free concerts at the Brookline Senior Center.

Brookline residents who want to lift their voices up and sing have the Coolidge Corner Community Chorus. The CCCC is open to anyone who wants to sing, regardless of their level of experience or previous training. Lee Colby Wilson, the choral director of the CCCC, writes, "It is our deep belief that musical excellence is not only possible, but essential to those who enter into the experience of great music with belief and trust in self and each other." Featured in this chapter is Florence "Flossie" Dunn, the former accompanist for the CCCC and a retired Brookline music teacher whose musical career took her around the world and back and had her conducting an all-male chorus in Boston.

Music can be an inspiring and a uniting force for people from all racial, cultural, and religious backgrounds. This was true for a legendary Brookline local named Roland Hayes—although he certainly faced more initial obstacles in the early to mid-twentieth century than he would have if he were alive today. Hayes (1887–1977) was a black concert tenor and composer. Born in Curryville, Georgia, Hayes's parents were former slaves who supported their seven children working as tenant farmers. Hayes's

interest in music stemmed from his experience singing in his church choir. After touring with The Jubilee Singers in 1911, he moved to Boston, where he thought the atmosphere might be more welcoming to a singer of color—however, he was to discover that racism existed in the North, too, and he was initially discouraged from pursuing a music career. Despite the challenges presented by racial segregation, Hayes built a successful career at home and abroad, eventually earning an enviable salary. He bought a house in Brookline in 1930, married, and had a child. When he retired, he purchased the farm in Georgia where his parents had worked as tenant farmers, bringing his life full circle.

Other notable stories of musicians who live in or hail from Brookline are featured here, including jazz pianist and composer Ran Blake. Blake is the head of the Contemporary Improvisation Department at the New England Conservatory of Music. He is an expert of the ear, specifically in developing and training the ear so a person can become a better musician and develop their own signature sound. His book *The Primacy of the Ear* (available on Lulu.com) includes his legendary "ear-robics" exercises.

A notable first, legendary local Rachel Childers was the first female brass player in the history of the Boston Symphony Orchestra. In an interview on WGHB's *The Callie Crossley Show*, Childers explains why she took to the French horn in fourth grade, despite the fact that she was already a budding pianist: "The French horn plays a lot of heroic roles, especially in movie music. The composers who write for the studios always give the French horn the best flicks! Whenever we do pop shows for kids, I get to play [music from] *Star Wars* and *Indiana Jones* and all that great stuff and you get to be that hero, that central figure. No offense to trombones but you don't want to be the evil trombone player!"

Boston Pops legend Harry Ellis Dickson was first violinist with the Boston Symphony Orchestra for 49 seasons—he would have liked to have made it 50 but management suggested he retire. In his obituary, *The New York Times* called Dickson "a witty raconteur" who served as an unofficial ambassador for classical music in the Boston area. He enjoyed a lifelong friendship with legendary Boston Pops conductor Arthur Fiedler, also a Brookline resident, who Dickson assisted. Dickson quipped in an interview, "I was probably as close to Arthur Fiedler as anybody ever got, and that wasn't very close."

Harry Ellis Dickson (1909–2003)
Harry Ellis Dickson, a child of Ukrainian immigrants, graduated from the New England Conservatory of Music. He began his career with the Boston Symphony Orchestra (BSO) in 1938 as a first violinist. In 1955, he became Arthur Fiedler's assistant conducting the Boston Pops, a relationship that would last for 44 years. Dickson was a champion of classical music for all ages, starting the BSO's Youth Concert Series in 1959 and serving as music director with the Boston Classical Orchestra. He also served as the music director of the Brookline Civic Symphony. In 1984, he published an account of his working relationship with Arthur Fiedler (also of Brookline) in *Arthur Fiedler and the Boston Pops* (Houghton Mifflin). Nationally, he became known as the father-in-law of former Massachusetts governor and presidential candidate Michael S. Dukakis. (Courtesy of Larry Ruttman, photograph by Jeff Thiebauth, www.jefftmusicphoto.com.)

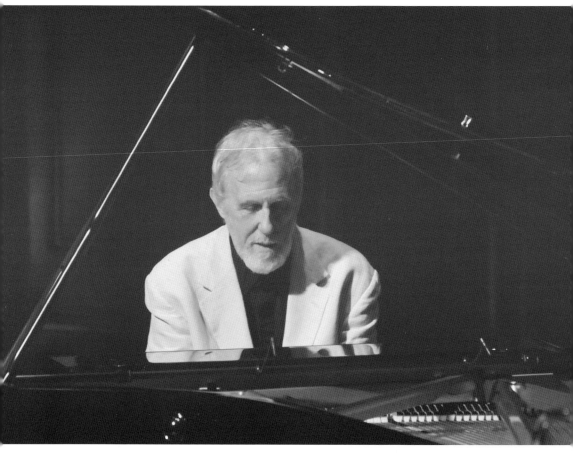

Ran Blake

Ran Blake is a pianist and composer, and has served on the faculty at the New England Conservatory (NEC) since 1967. His music has a signature style, which includes his own blend of jazz, blues, gospel, and classic film noir scores. His 40-year friendship with Gunther Schuller was strengthened by their dedication to what Schuller coined "Third Stream" jazz. In 1973, Blake and Schuller, both at the NEC, founded the Department of Third Stream. Blake became the department chair, a position he still holds today. Blake has recorded more than 30 albums, most as a solo pianist; however, a notable exception was his 2001 album *Sonic Temples*, which featured both of his jazz musician sons playing backup. It was Blake's best-received and most critically acclaimed album in years. (Courtesy of Andrew Hurlbut/New England Conservatory.)

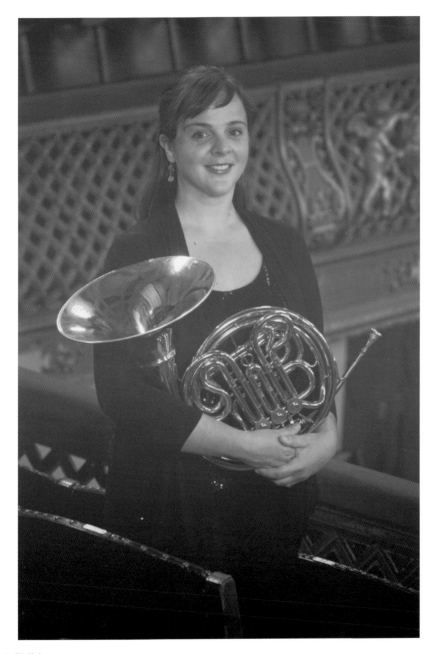

Rachel Childers

Rachel Childers is the first female member of the Boston Symphony Orchestra's brass section in its 132-year history. She has also played her French horn with the Boston Classical Orchestra. Childers first picked up the brass instrument as a fourth grader after she learned that she needed to take private lessons in order to be in the school band. Childers told *Boston Globe* reporter Geoff Edgars that "horn traditionally was more of a masculine instrument because of the physicality of how it's played." She also blames the lag in hiring a female brass player on the low turnover in the BSO. When asked about the fuss that has been made of her status, she said, "I hope that it's not the only thing I accomplish with the BSO, but it's a pretty good way to start." (Courtesy of Stu Rosner.)

Osvaldo Golijov

Osvaldo Golijov is a musical composer. He was born in La Plata, Argentina, into an Eastern European Jewish family. Golijov's mother was a piano teacher, and young Osvaldo was raised surrounded by music—classical chamber music, Jewish liturgical, klezmer music, and the tango of Astor Piazzolla. He studied piano at the local conservatory and at the Jewish Rubin Academy in Israel. After moving to the United States in 1986, he earned his doctorate at the University of Pennsylvania. He is the recipient of a MacArthur Fellowship and has earned Grammy nominations for his work with both the St. Lawrence and Kronos String Quartets. In the winter of 2006, *The Passion of Osvaldo Golijov*, which featured multiple performances of his work, played to sold-out crowds at New York City's Lincoln Center. Golijov is Loyola Professor of Music at College of the Holy Cross in Worcester, Massachusetts. (Courtesy of Tanit Sakakini.)

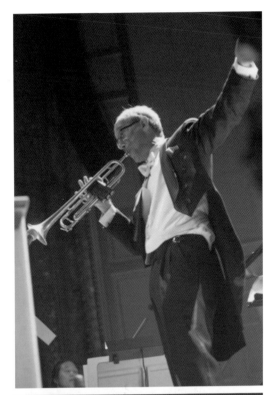

Bo Winiker
Bo Winiker is a trumpet player. From the time he was nine, Bo and his older brother Bill (on drums) have been playing music together. From 1977 to 1991, Bo and Bill played the Parker House Hotel to packed crowds of tourists and college students, and they performed backup for Aretha Franklin at Bill Clinton's inaugural ball in 1993. Now, they are the go-to musicians for any big Boston event. (Photograph by Theresa Johnson Herlihy, courtesy of Bo Winiker.)

Peter Welker
The son of two professional jazz musicians, Peter Welker went to Brookline High School. He first picked up the trumpet at age nine. Over his career, he has played/recorded with legendary acts like Van Morrison, Santana, Buddy Miles, and Dr. John. He credits his mother, who was born blind, as being the major influence on his life and musical career. He currently lives and performs in the San Francisco bay area. (Courtesy of Peter Welker.)

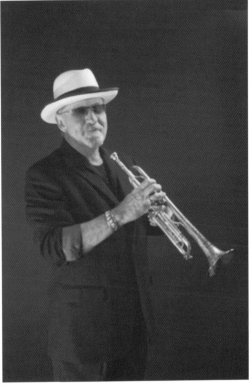

Johanna Hill Simpson

Johanna Hill Simpson is a conductor and the founder of PALS Children's Chorus in Brookline. She studied music at Dartmouth and choral conducting at the New England Conservatory. In 1990, she founded PALS. For 16 years, Simpson and PALS collaborated with acclaimed composers and musicians like James Levine, Celine Dion, Keith Lockhart, and Nathan Lane, and PALS became known across the country as one of the finest youth ensembles around. Simpson is now the artistic director of music on Norway Pond but remains an artistic consultant with PALS. She lives in Hancock, New Hampshire, with her husband, tenor Rick Simpson, and her standard poodle, Pearl. (Courtesy of Jörg Meyer.)

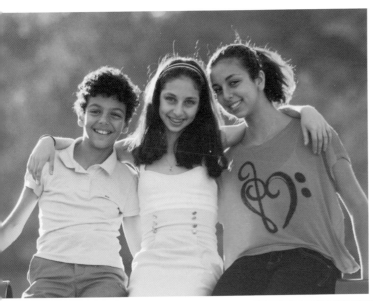

The Siraj Siblings
One cannot help but be impressed by the Siraj siblings (from left to right): Amir, Yasmin, and Layla. The Sirajs are not only multitalented and smart—they are also down to earth about their talents. All three are accomplished pianists and athletes. Amir rows, and Layla and Yasmin figure skate. They are also exceptional students. Layla is a sophomore at Harvard University, and her sister Yasmin will be a freshman there in fall 2014. (Courtesy of Stephen Carrier.)

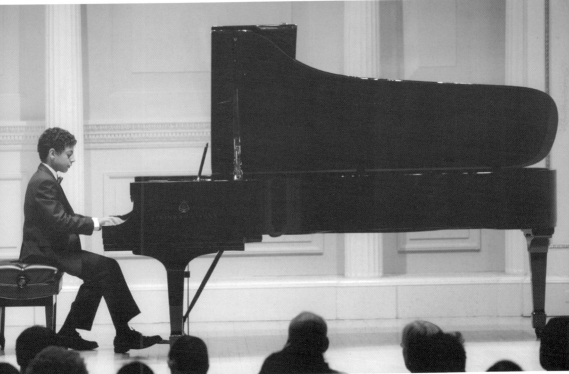

Amir Siraj
Amir Siraj has played at Carnegie Hall three times and at Symphony Hall once, and he is only a teenager. Amir started taking piano lessons at age four and continues to study locally with Helena Vesterman of Newton and A. Ramon Rivera at the New England Conservatory. He also enjoys competitive rowing. This photograph shows Amir playing at Carnegie Hall. (Courtesy of the National American Fine Arts Festival.)

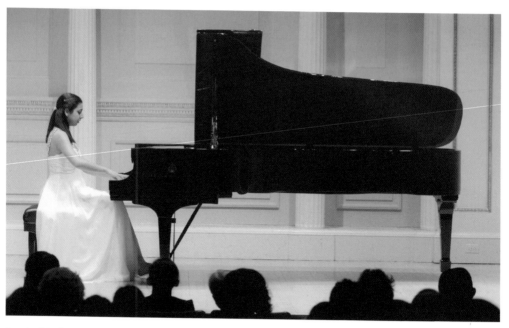

Layla Siraj

Layla Siraj is a pianist, figure skater, and Harvard University student. Layla has played piano at Carnegie Hall as part of the American Fine Arts Festival and placed in the top three performers at the Music Teachers National Association competition. In high school, she was the winner of numerous awards for mathematics, physics, and chemistry. She placed seventh in the 2011 New England Regional Figure Skating Championships. (Courtesy of Aban Makarechian.)

Yasmin Siraj

Yasmin Siraj is a talented pianist and figure skater. In January 2014, she competed in the US Figure Skating Championship for a spot on the Olympic team, where she earned a 95.06 in the free skate, finishing in 16th place. She took her first steps on the ice at just three years old and has loved skating ever since. Yasmin has performed three times at Carnegie Hall alongside her brother Amir. (Courtesy of Daniel Scott Booth.)

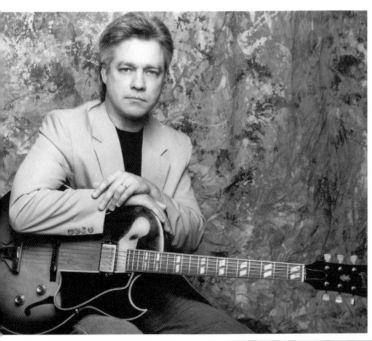

Stephen "Steve" Rochinski
Stephen Rochinski is a self-taught bebop jazz guitarist. His grandfather, a songwriter, was an early influence, but his most singular teacher was Tal Farlow. He studied with Farlow (for which he received a Jazz Fellowship from the National Endowment for the Arts) and performed at the JVC Jazz Festival 75th birthday tribute concert for Farlow at Merkin Hall in New York City. He is a professor at Berklee College of Music. (Courtesy of Steve Rochinski.)

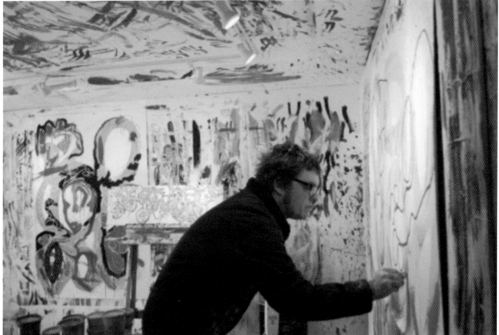

Mikey Welsh (1971–2011)
Mikey Welsh played bass for the rock band Weezer. He met front man Rivers Cuomo in Boston in 1997 and performed live with the band in 2000. He was the bassist on Weezer's self-titled third album (sometimes called "The Green Album") but struggled with mental health issues and quit the band in 2001. He had success as a visual artist before his life was tragically cut short by a suspected drug overdose in 2011. (Photograph by Danielle DeMarse-Welsh.)

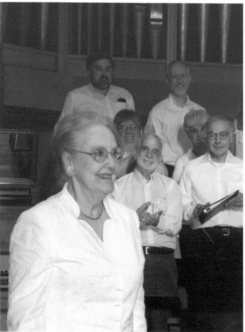

Florence "Flossie" Dunn

Look at any picture of Florence "Flossie" Dunn and one will immediately see it—her love of life, especially when it is filled with music, fun, and friends. In a recent photomontage assembled by the New England Conservatory of Music on the occasion of her 90th birthday, every picture of Dunn shows a handsome, beaming woman. She earned both bachelor's and master's degrees at the NEC, where she studied keyboard. She traveled around the world as an accompanist, and for decades, she conducted the all-male chorus in the Apollo Club of Boston. She recently ended her run as accompanist and associate director of the Coolidge Corner Community Chorus, an open choir that does not hold auditions; everyone who wants to sing is welcome.

Florence "Flossie" Dunn served as dorm mother at the NEC in 1960. (Above, courtesy of the New England Conservatory Archives; left, courtesy of the CCCC.)

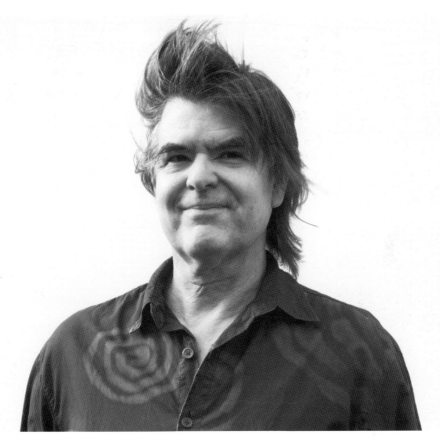

Roger Clark Miller
Roger Clark Miller is a renaissance man; he is a musician, artist, writer, and composer. He is best known for his work with Mission of Burma, the band he cofounded. Since 1980, he has released over 50 albums, crossing into multiple genres like avant-punk and piano-based music. Miller's time as a legendary local here was brief. Originally from Ann Arbor, Michigan, he was a Brookline resident for one and a half years—from the fall of 2007 to the spring of 2009. Miller lived with former film teacher Dave Klieler, who was instrumental in saving the Coolidge Corner Theater from closing its doors for good in 1988. During his time in Brookline, Miller worked on Mission of Burma, the Alloy Orchestra, and "Snakes Dream Sky," his first composition to premier at the New England Conservatory. (Courtesy of 3 Graces Productions.)

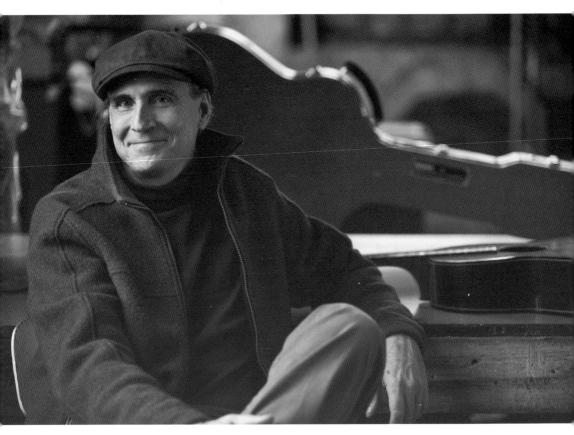

James Taylor

James Taylor is an American singer, songwriter, guitarist, and recording and touring artist. His songs, like "Fire and Rain," "Country Road," "Carolina in My Mind," and "Sweet Baby James," are classic folk-rock tunes. Taylor has earned 40 gold, platinum, and multiplatinum awards and five Grammy Awards spanning his musical career. In 2000, he was inducted in the Rock and Roll Hall of Fame and the Songwriters Hall of Fame and performed at both of Pres. Barack Obama's inauguration ceremonies. He owns a house in Brookline and in Western Massachusetts, which he shares with his wife, Caroline, and their sons Henry and Rufus. (Courtesy of James O'Mara.)

CHAPTER FIVE

Politics and Social Good

Brookline has had US ambassadors, two Massachusetts governors, an attorney general, a lieutenant governor, university presidents, and the 35th president of the United States.

Many politicians get their start by being elected to the Brookline Town Meeting. Legendary local Michael Dukakis, governor of Massachusetts and candidate for the presidency, was one. The town Meeting is Brookline's legislative arm of government. It consists of 240 elected members, plus members of the board of selectmen and any state representative or senator who lives in the town. Each of Brookline's 16 precincts gets to elect 15 members. It is a system that, to this day, has worked out very well for the town.

The most famous political family associated with Brookline is the Kennedys. Joe and Rose Kennedy moved to 83 Beals Street after they were married, and in the six years they lived there, they had four children: Joseph Patrick Jr., John Fitzgerald, Rosemary, and Kathleen Agnes. The family then moved to a larger home on Abbottsford and more babies arrived, until the family counted 11 members in all. Three Kennedys are highlighted in this chapter.

Much has already been written about the Kennedy legacy. But going back further in history, we find other powerful and influential clans hailing from Brookline and Boston. The Welds are one such family. William Weld served as governor of Massachusetts from 1990 to 1997. His ancestor, Isabel Weld Perkins, was once the wealthiest woman in the country. They came from a family of Harvard graduates and philanthropists with strong ties to the formation of the country.

Reaching further back in Brookline history, we find the Aspinwalls. Col. Thomas Aspinwall (1786–1876) is a direct descendent of Peter Aspinwall, the first man of that name to settle in Brookline. Thomas's father, Dr. William Aspinwall, was a physician credited with discovering an effective inoculation against smallpox. Thomas Aspinwall was a Harvard graduate before the age of 20. He worked for a time at the law office of William Sullivan and soon became a partner, which led him to open up his own practice. When the War of 1812 broke out, Aspinwall left his law firm and made himself available to fight for his country. He eventually made colonel and also lost his arm in the defense of Fort Erie in 1814. That same year, he married Louise Elizabeth Poignand and they had seven children. After the war, Colonel Aspinwall was appointed by Pres. James Madison to become consul to London in 1815. At the time of his death, the colonel was the oldest survivor among the officers of the War of 1812. He is buried in the Walnut Hills Cemetery on Grove Street and Allandale Road in Brookline. Colonel Aspinwall is famous for saying, "In history, truth should be held sacred, at whatever cost . . . especially against the narrow and futile patriotism, which instead of pressing forward in pursuit of truth, takes pride in walking backwards to cover the slightest nakedness of our forefathers."

The Sewall family name dates to the incorporation of Brookline in 1705. Samuel Sewall Jr. (1678–1751) headed the petition to establish Brookline as a separate town. Sewall served as the town's first clerk, and later became treasurer and selectman. In this capacity he continued to shape the town, helping to designate a burial area and school grounds.

Of course, there are the less-well-known names that still earn at least a footnote in Brookline history. We've all heard of the midnight ride of Paul Revere, but what about the ride of William Dawes? Though he was never a Brookline resident, Dawes is considered an honorary hero in this town because of his

famous ride to warn Samuel Adams and John Hancock that an impending British raid was planned. History has not been kind to Dawes, a militiaman and tanner by trade, whose role in the heroic night ride has been overshadowed by Paul Revere's. Unlike Dawes, Revere left detailed notes of his evening's escapades and was later singled out by Henry Wadsworth Longfellow in his poem "Paul Revere's Ride." The story goes that on the night of April 18, 1775, Dr. Joseph Warren sent Revere and Dawes to Lexington on different routes to ensure at least one arrived safely. Dawes's ride took him through Brookline, among other towns. The British eventually captured Revere, but Dawes outwitted them. Dawes had a wife and seven children. He died in 1799 at the age of 53. On Patriot's Day in Brookline there is an annual re-enactment of William Dawes's ride—perhaps to afford some bit of posthumous glory to an otherwise obscure historical figure.

Recalling the great figures of the temperance movement, perhaps only the most colorful characters leap to mind, like Carrie Nation with her hatchet. Brookline's Anna Mellen Stearns (1840–1924) was a staunch advocate for the temperance movement, belonging first to the Sons of Temperance and then to the Brookline branch of the larger Women's Christian Temperance Union (WCTU), of which she also served as president. Under her leadership, the WCTU opened a Free Temperance Reading Room, which at that time served as an alternative to the rowdier public houses. That led to the building of a larger structure for club meetings, called the Union Building, which opened in 1888 on the corner of High and Walnut Streets. It still stands today.

Philanthropy and a generosity of spirit is what made these and other influential families in Brookline's history so memorable. Generosity does not require great wealth. There are legendary locals in Brookline who give or have given of their intelligence, time, talent, and energy for the good of their neighbors. Lovin' Spoonfuls, The Brookline Emergency Food Pantry, and Feed Brookline are just a handful of examples of organizations led by ordinary citizens who are making a difference in the community. Legendary local Ashley Stanley is the founder of Lovin' Spoonfuls, a nonprofit organization that facilitates the recovery and distribution of healthy, perishable food that would otherwise be discarded. Lovin' Spoonfuls works efficiently to deliver this food directly to the community organizations and resources where it can have the greatest impact. Since founding Lovin' Spoonfuls in 2010, Ashley and her team have distributed over one million pounds of fresh, healthy food to those in need.

"My heart is full." That is what Rene Feuerman's eight-year-old daughter, Olivia, said to her mother after they delivered 50 bags of food to the Brookline Emergency Food Pantry in St. Paul's Episcopal Church. That simple but profound statement from her daughter inspired Feuerman to start volunteering at the pantry, eventually becoming its director. Feuerman moved to Brookline in 1989 and worked as a financial planner for JP Morgan Chase for 12 years before making the transition to staying at home to raise her children. The demand for the pantry's services has more than doubled since 2009, but Feuerman makes sure the pantry is always fully stocked, not only with canned goods and dried pasta, but also fresh fruits and vegetables. Working at the food pantry does take some time away from her kids, Feuerman admits, but the rewards she gets from working there have changed her life.

Edward Devotion (1621–1685) and Edward Devotion Jr. (1668–1744)

The Devotion House, 347 Harvard Street, serves as a museum and the headquarters of the Brookline Historical Society, which held its first meeting there in 1901. The house dates from around 1740, but its interior structure may have been erected in 1680. As such, it is one of the oldest structures in Brookline; the town purchased it in 1891.

Edward Devotion Sr. settled in Brookline around 1650. According to Brookline Historical Society proceedings, he was a planter who received his first 11 acres of land from Cotton Flacke in 1654. Devotion was active in town affairs, serving on committees to officially inspect town boundaries and oversee fences. He was also a constable and a tithing man.

Devotion Sr. had two sons, Edward Jr. and John. Edward Jr. bequeathed land to the town for public schooling—that gift is now Devotion Elementary School. (Author's collection.)

Isaac Adams (1793–1855)

Isaac Adams was one of Brookline's first schoolmasters. This passage from Harriet F. Wood's *Historical Sketches of Brookline* (1920) suggests that Adams believed in the adage "spare the rod, spoil the child:"

> No one seems to retain a very clear idea of the studies pursued or of anything interesting in the teaching. Of the discipline, however, there is a most vivid recollection. School was opened with a long, extemporaneous prayer, by the master. During this prayer, nothing escaped his vigilant ears, eyes and nose, and the slightest sound or trick was traced to the right source. After prayers, the next proceeding generally was to punish somebody for something real or imaginary.

Adams may have reserved his tender side for his wife, Martha Washington Hill. When she died, Adams changed his name to "Isaac Mahtra Wanshongtri Adams" to incorporate her name into his own. (Author's collection.)

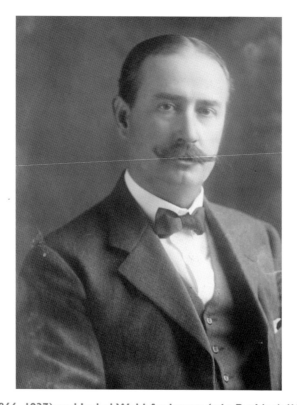

Larz Anderson (1866–1937) and Isabel Weld Anderson (née Perkins) (1876–1948)

Larz and Isabel Anderson's lives were marked by both great wealth and great charity and public service. Both born into wealthy American families with deep roots in the creation of this country, they did not waste their privilege. Future diplomat Larz Anderson, son of the Civil War general Nicholas Longworth Anderson, attended Phillips Exeter Academy and Harvard University. It was on his year-and-a-half world tour as a young man that he developed a thirst for travel and international affairs. He became second secretary of the American Legation in London in 1891, and three years later, he became first secretary of the embassy in Rome, where he met Isabel, who was on her grand European tour. Larz eventually served as US minister to Belgium and US ambassador to Japan. For his diplomatic efforts, he was awarded the Order of Saints Maurice and Lazare (Italy), the Order of the Crown (Italy), Order of the Rising Sun (Japan), and Order of the Crown (Belgium). At home, upholding his family's tradition of patriotic and military service, Larz volunteered for the US Army during the Spanish-American War and contributed to World War I relief efforts.

Isabel Weld Perkins was only five years old when she became the wealthiest girl in America. The Weld family was one of the oldest and most prominent in New England. Isabel's paternal grandfather, the shipping magnate William Fletcher Weld, died and left her a great fortune, which she collected on her 21st birthday. Isabel volunteered for the Red Cross during World War I, caring for the sick and wounded in France and Belgium. Later, she would tend to the afflicted during the American influenza epidemic. She received the American Red Cross Service Medal, Croix de Guerre (France), and the Medal of Elisabeth of Belgium. Later in her life, Isabel would write nearly 40 books, predominantly children's books and travelogues.

The Andersons loved travel above all else, but they also enjoyed automobiles, airplanes, theater, and collecting art. They had three homes, one in Washington, DC; one in the Whites of New Hampshire; and an estate in Brookline, now home to the Larz Anderson Auto Museum—the oldest car collection in the United States—and a public park operated by the town of Brookline. (Courtesy of Larz Anderson Auto Museum, Photographic Archives.)

Katherine A. Morey

Katherine Morey served as chairman of the Massachusetts State Branch of the National Woman's Party. In *Jailed for Freedom* (1920), Doris Stevens writes about a particular demonstration in Boston the day Pres. Woodrow Wilson was visiting the city; the young suffragist, along with 21 other women, implored President Wilson to push for an amendment granting women the right to vote:

> "When we had stood there about three quarters of an hour," said Katherine Morey, "Superintendent Crowley came to me and said, 'We want to be as nice as we can to you suffragette ladies, but you cannot stand here while the president goes by, so you might as well go back now.' "

The "suffragette ladies" did not go back, and several of them, Morey included, were arrested and sentenced to eight days in the Charles Street jail. Pictured here from left to right are Morey; Elsie Hill, of Norwalk, Connecticut; and Mrs. Wm. H. Blauvelt, of Syracuse, New York, state chairman of the Woman's Party. (Courtesy of the Library of Congress.)

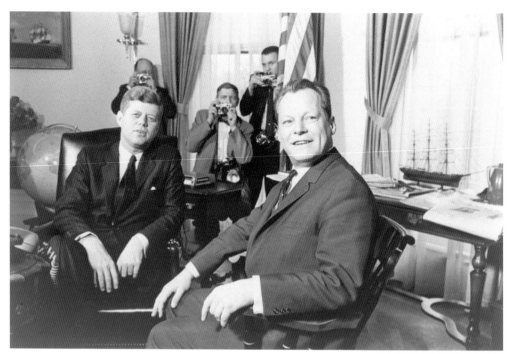

John F. Kennedy (1917–1963)

John Fitzgerald Kennedy was born at 83 Beals Street in Brookline. He was the second of nine children born to Joseph P. Kennedy Sr., a successful banker, and Rose Elizabeth Fitzgerald, a Boston debutante and daughter of John "Honey" Fitzgerald, the mayor of Boston. John served in the US House of Representatives and the Senate before beating Richard Nixon to become the 35th president of the United States. At 43, he was the youngest elected president and the only Catholic. Kennedy's term was marked by foreign strife—the Cuban missile crisis in particular—but he is arguably one of the most popular presidents of all time. On November 22, 1963, an assassin's bullets tragically ended his life at the age of 46. Kennedy, a Democrat, famously said, "Let us not seek the Republican answer or the Democratic answer, but the right answer." Kennedy is pictured above at left with Mayor Willy Brandt of Berlin, Germany. (Both, courtesy of the Library of Congress.)

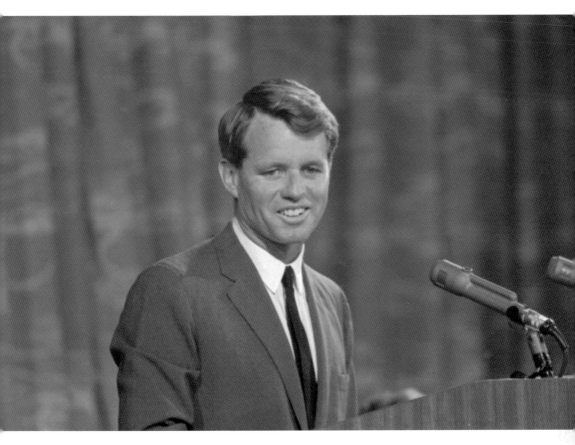

Robert F. Kennedy (1925–1968)
Robert Francis Kennedy was born in Brookline. Bobby was his older brother John's closest confidante during John's presidency. Bobby helped John get elected, and John appointed Bobby US attorney general. Bobby briefly attended Harvard University, but his education was interrupted by his service in the Navy during World War II. In 1946, Bobby returned to Harvard and graduated, went to law school, and married Ethel Skakel. Bobby was an advisor to the Senate Subcommittee on Investigations under Sen. Joseph McCarthy but resigned because of his disapproval of McCarthy's tactics. He later uncovered corruption by Teamsters union leader Jimmy Hoffa and served as a New York senator. In 1968, shortly after Bobby had clinched the democratic candidacy for president, Palestinian extremist Sirhan Sirhan assassinated him at the Ambassador Hotel. Bobby's first words after being shot were "Is everybody OK?" (Courtesy of the Library of Congress.)

Joseph P. Kennedy (1888–1969)
Joseph Patrick Kennedy was a businessman, politician, and patriarch to one of the nation's most famous families. By 25, he was a bank president and by 30 a millionaire, earning his fortune in the movie business and alcohol distribution. He married Rose Fitzgerald and started a family in Brookline. He taught his nine children to be interested in the world, encouraging them to discuss national issues at the dinner table. (Courtesy of the Library of Congress.)

Ray Atherton (1883–1960)
Born in Brookline, Ray Atherton was the first US ambassador to Canada. He also served as minister plenipotentiary to Bulgaria and Denmark. As a young man, he studied architecture in Paris and worked as a banker. In 1917, he became a secretary of legation, and after moving to London, he worked at the US embassy as a secretary and counselor. He married Maude Hunnewell, and they had two children. (Courtesy of the Library of Congress.)

Paul and Theo Epstein

Born and raised in Brookline, twin brothers Paul and Theo Epstein are the founders of the Foundation to be Named Later, which supports nine different nonprofit organizations. Nicknamed "Boston's Big Brother," Paul Epstein is a social worker at Brookline High School. He has served as a Big Brother twice—an experience that first inspired him to become a social worker. Paul worked in residential treatment at Boston's Home for Little Wanderers, where he met his wife, Saskia, and is the president of the Brookline Teen Center. Theo Epstein is the president of baseball operations for the Chicago Cubs. He is also the former general manager of the Boston Red Sox. At 28, Epstein was the youngest general manager in baseball history, and when the Red Sox won the World Series in 2004, Epstein was the youngest general manager to win a championship. (Left, photograph by Larry Ruttman; below, photograph by Scott Slingsby, courtesy of slingsbyimages.com.)

Jean Baker Miller (1927–2006)

Jean Baker Miller was a psychoanalyst and author. She wrote *Toward a New Psychology of Women*, a groundbreaking text detailing her "Relational-Cultural" theory of female psychology. Miller's theory proposed that women's depression could be assuaged through the building of positive relationships, including their relationships with their therapists, who should strive to create an atmosphere of empathy and acceptance. Born in the Bronx, Miller earned degrees from Sarah Lawrence College and Columbia University. Over the course of her career, she owned private practices in New York and Boston, taught psychology at Boston University School of Medicine, lectured at Harvard Medical School, and was the founding director of the Jean Baker Miller Training Institute in Wellesley. Her husband, S.M. Miller, is an emeritus professor of sociology at Boston University. Miller died of respiratory failure at age 78 in her home in Brookline. (Courtesy of Wellesley Centers for Women, Wellesley College.)

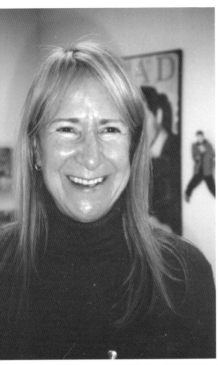

Margot Stern Strom
Margot Stern Strom is the president emerita and senior scholar of Facing History and Ourselves, an organization whose mission is to use education to combat bigotry and nurture democracy. A former teacher at the Runkle School, Stern Strom became interested in developing lessons and classroom resources that focus on historical events that some textbooks gloss over, like the devastation of the Holocaust. Today, classrooms worldwide benefit from these resources. (Photograph by Larry Ruttman.)

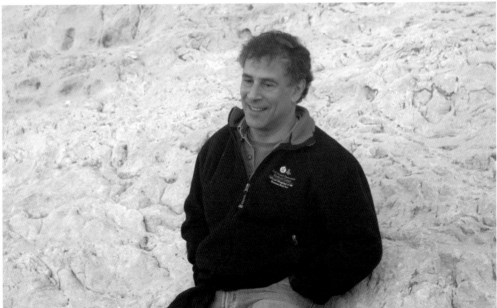

David Eppstein
David Eppstein is a recent honoree of the Action for Boston Community Development (ABCD), an antipoverty agency. For more than 15 years, Eppstein has been a volunteer with the ABCD Parker Hill/Fenway Neighborhood Services Center Food Pantry. As the former vice president of operations for the Medical Academic and Scientific Community Organization, Eppstein also arranged a yearly donation from the organization to benefit the ABCD SummerWorks program. (Courtesy of David Eppstein.)

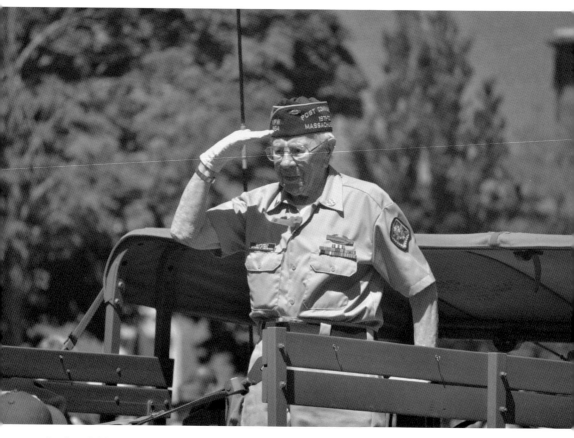

Arthur J. Hurley Jr. (1924–2013)
Arthur J. Hurley Jr. was a lifelong Brookline resident and one of the town's most decorated war veterans. He was a fixture in his Army uniform at the town's veterans' ceremonies. An infantryman in World War II, Hurley served in Italy, Southern France, and Central Europe, earning a Silver and Bronze Star and four campaign medals. In civilian life, he worked in the water department and as a crossing guard. Veterans' affairs director Bill McGroarty praised Hurley in the *Brookline Tab*: "He was the heart and soul of the veterans' community. He was always there for everyone." McGroarty then added, "More than just being a hero in war, he was a hero in peace." (Courtesy of Patty Parks.)

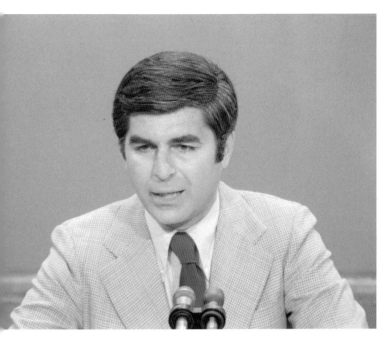

Michael Stanley Dukakis and Katharine "Kitty" Dukakis (née Dickson)
Michael Stanley Dukakis is the former governor of Massachusetts, a four-year position he held three times (1975–1979 and 1983–1991). In 1988, he and running mate Lloyd Bentsen from Texas ran on the Democratic ticket for president but lost to George H.W. Bush and Dan Quayle. Dukakis was born into a Greek-Orthodox family and raised in Brookline, where he attended public schools. A graduate of Swarthmore College and Harvard Law School, Dukakis started his political life when he was elected to serve at Brookline town meetings. Later, he joined the Massachusetts House of Representatives, where he served from 1962 to 1970. Dukakis married Kitty Dickson in 1963, and they had two daughters.

Katharine "Kitty" Dukakis was born in Cambridge, Massachusetts, to conductor and violinist Harry Ellis Dickson and Jane Dickson. She had a brief marriage to her high school sweetheart, and they had one son, but the couple divorced four years later. As first lady of Massachusetts and later a national figure as the wife of a presidential nominee, Kitty was a polished, extroverted woman but secretly she battled depression and addiction—first to diet pills, which she quit after a stay at Hazelden in 1982, and then alcohol, which she kicked in the early 1990s. She would later become a social worker and accept a position at the International Institute of Boston to help immigrants and refugees. Kitty is also the author, with Jane Scovell, of the book *Now You Know* (1990) about her struggles with depression and addiction, and the coauthor, with Larry Tye, of *Shock* (2007), which is about how electroconvulsive therapy helped ease her chronic depression. In 2007, the Lemuel Shattuck Public Health Hospital in Jamaica Plain established the Kitty Dukakis Treatment Center for Women.

Michael and Kitty Dukakis live in Brookline. They recently celebrated Mike's 80th birthday. In a continuing effort to support children with autism spectrum disorder, they used the occasion to hold a fundraiser for the New England Center for Children, which provides education and research into the disorder. Remarking on the progress of the center to the *Brookline Tab*, Michael Dukakis said he was very gratified; "being able to touch lives in a positive way is what life is all about." (Left, courtesy of the Library of Congress; right, photograph by Ellen Dallager.)

Evelyn Murphy
When Evelyn Murphy was elected the 67th lieutenant governor of Massachusetts, she became the first woman in the history of the state to hold a constitutional office. Murphy, a graduate of Duke and Columbia Universities with a doctorate in economics, is also the founder of Women Are Getting Even, a national grassroots organization to end wage discrimination against working women. She is the author of *Getting Even: Why Women Don't Get Paid Like Men and What to Do About It* (2005). Murphy is the vice-chair of the board of directors of Savings Bank Life Insurance Mutual Life Insurance Company and a director of Citizen's Energy Corporation. She is also a member of the International Women's Forum and the Boston Club. In what can only be a very small modicum of spare time, Murphy runs marathons and follows the Red Sox. (Courtesy of Evelyn Murphy.)

Jack Corrigan

Jack Corrigan is a veteran of Democratic politics in Massachusetts. A graduate of Harvard University and Harvard Law School, Corrigan was a senior member in the 1988 presidential campaign for Michael Dukakis, as well as presidential nominee John Kerry's point person at the 2004 Democratic National Convention in Boston. Originally from Somerville, Corrigan got to know Brookline when he was assigned to the Brookline Municipal Court as a Norfolk County assistant district attorney. He told Larry Ruttman in *Voices of Brookline*, "I worked with some very impressive public servants in Brookline, the police department, the fire department, the town employees." In fact, Corrigan liked Brookline so much, he bought a house and raised a family here. (Photograph by Larry Ruttman.)

Vicki Milstein

Vicki Milstein is the principal of the Brookline Early Education Program (BEEP). She is a recent winner of the Brookline Education Foundation's Robert I. Sperber Award for Administrative Leadership. Milstein has served as an administrator of BEEP for 16 years, overseeing 22 prekindergarten programs enrolling more than 320 students, as well as Brookline's kindergarten classes. She was named the first principal of BEEP and has also been a classroom teacher and a consultant for public and independent schools. The Sperber Award recognized Milstein's enthusiastic support of "an inclusive environment that honors each child's unique path to achievement." She is only the fourth recipient of this award in the past 15 years. (Courtesy of the Brookline Education Foundation.)

Sarah Gladstone
A teenaged Sarah Gladstone started the Starfish Project, raising money to benefit young women suffering from Obstetric Fistulas. Gladstone read about the condition—which causes incontinence and often leads to social ostracism—in the book *Half the Sky* (2009). The condition is easily treatable with a surgical procedure costing $450. Gladstone started making and selling bracelets using paper beads made by Cambodian women. She was awarded the 2012 Brookline Youth Award. (Courtesy of Sarah Gladstone.)

Ashley Stanley
Brookline's Ashley Stanley is the founder and executive director of Lovin' Spoonfuls, an organization that facilitates the recovery and distribution of healthy, perishable food that would otherwise be discarded. A former athlete, Stanley worked in luxury retail before founding Lovin' Spoonfuls in 2010. The organization was a two-time winner of the 2012 MassChallenge competition, among other distinctions. Stanley was recently named one of Oxfam International's Sisters of the Planet ambassadors. (Courtesy of Lovin' Spoonfuls.)

Lester Lefton
Lester Lefton is the 11th president of Kent State University in Ohio, one of the nation's largest university systems. Before Kent State, Lefton was senior vice president for academic affairs and provost at Tulane University, dean of George Washington University's College of Arts and Sciences, and dean of the University of South Carolina's College of Liberal Arts. (Courtesy of Kent State University.)

Sumner Kaplan (1920–2011)
In 1954, Sumner Kaplan made Brookline history by becoming the first Democrat elected to the Massachusetts House of Representatives. Kaplan, who lived most of his life in Brookline, had been a brigadier general in the Army Reserve. He also served as a Brookline selectman and a probate and family court judge. (Photograph by Larry Ruttman.)

IN MEMORY OF
JOSEPH McMURRAY
A BROOKLINE POLICE OFFICER WHO
MADE THE ULTIMATE SACRIFICE FOR HIS
COMMUNITY

BORN ON SEPTEMBER 11, 1862
APPOINTED A POLICE OFFICER ON MAY 1, 1893
KILLED IN THE LINE OF DUTY ON OCTOBER 17, 1904

PLACED BY THE BROOKLINE POLICE ASSOCIATION • 1992

Joseph McMurray (1859–1904)

Though Joseph McMurray died over a century ago, his name is still spoken among Brookline policemen. Officer McMurray, a husband and father of seven children, was shot and killed in the line of duty after it was reported that a "rum-crazed" man, city laborer Harry Boles, had shot and killed his wife, Ann Boles. The kicker? McMurray had saved his assailant from drowning three years prior. (Courtesy of the Brookline Historical Society.)

Daniel C. O'Leary

Daniel C. O'Leary is the chief of police of the Brookline Police Department. O'Leary is a Brookline native, one of six children growing up on Somerset Road. He was a student at St. Mary's and Brookline High School. O'Leary told the following to Larry Ruttman in *Voices of Brookline* (2005): "I had a real good time growing up in Brookline. Brookline is great for kids. My memories really revolved around the playgrounds and parks." (Photograph by Larry Ruttman.)

Michio Kuchi and Aveline Kuchi
Michio and his first wife, Aveline Kuchi, are credited with introducing the macrobiotic and natural foods movement to the United States. After witnessing the destruction of Hiroshima at the end of World War II, young Michio was determined to make a positive impact on the world. He started promoting healthy life choices like a whole-foods diet, exercise, and simple living. He found that people who followed this lifestyle were more peaceable than meat eaters. The Kuchis gave lectures in their home, taught cooking classes, and opened up a small chain of natural food stores. Nowadays eating tofu and shopping locally are mainstream, and many of the brands found at the supermarket, like Kashi and Horizon Organics, exist in part because of the Kuchis' influence. Aveline Kuchi died in 2001. Michio lives in Brookline with his second wife, Midori. (Both, courtesy of the Kuchi Institute.)

Claire Willis

Claire Willis, a Brookline resident, is a clinical social worker, an ordained lay Buddhist chaplain, and a yoga teacher. She is the author of *Lasting Words: A Guide to Finding Meaning Toward the Close of Life* (Green Writers Press, 2013). For over 25 years, she has worked with oncology patients and clients dealing with end-of-life issues in her private practice. A cofounder of Facing Cancer Together: A Community of Hope, Claire is also an adjunct faculty member at the Andover Newton Theological School. She earned a master's from Episcopal Divinity School and a master's of social work and a master's of education from Boston University. When asked why she lives in Brookline, Willis said, "The [Brookline] Booksmith, the [Coolidge Corner] Cinema—everything you want you can walk to. I love the vibrancy of the intellectual community here. I raised my kids here." (Photograph by Marnie Crawford Samuelson, courtesy of Green Writers Press.)

Steven Rothstein

Steven Rothstein is a Brookline High School graduate, class of 1974, who served as president of the Perkins School for the Blind in Watertown from 2003 through the 2013–2014 school year. He was a cofounder of Citizens Energy Corporation, a nonprofit organization that provides energy and medical benefits to low-income citizens nationally and internationally. He was also an assistant commissioner of the Massachusetts Department of Mental Retardation and served on the Massachusetts Board of Education. While at Perkins, Rothstein developed leadership positions in a variety of organizations that serve individuals who are blind and deaf in the United States and internationally. Rothstein currently lives in Brookline with his wife, diversity activist and lawyer Susan Maze-Rothstein. They have two sons. (Photograph by David Gordon Photography, courtesy of Perkins.)

Susan Linn

Dr. Susan Linn is a difficult local legend to categorize. As the cofounder and director of the Campaign for a Commercial-Free Childhood, an instructor in psychiatry at Harvard Medical School, and a psychologist, Linn has educated parents, students, and teachers about the ill effects of media and commercial marketing on children and worked to reduce marketers' access to kids. As a writer, she has authored two critically acclaimed books: *Consuming Kids: The Hostile Takeover of Childhood* (The New Press, 2004) and *The Case for Make Believe: Saving Play in a Commercialized World* (The New Press, 2009), which the *Boston Globe* called "a wonderful look at how play can heal children."

Dr. Linn is also an award-winning ventriloquist and children's entertainer. Linn began practicing ventriloquism when she was 11 years old. She has appeared on *Mister Rogers Neighborhood* along with her costar, Audrey the Duck, and created public service announcements on child development for television networks. She has also performed at the Brookline Puppet Showplace Theatre, a nonprofit performing arts organization committed to excellence in puppetry for all audiences.

Linn is internationally known for her innovative work using puppets in child psychotherapy. She pioneered this work at Boston Children's Hospital and at the Children's AIDS Program in Boston. Her work has been featured on *60 Minutes*, *Now with Bill Moyers*, *Good Morning America*, *Today*, *The Colbert Report*, *Dateline*, *World News Tonight*, and in the acclaimed 2003 Canadian documentary *The Corporation*. In 2006, Dr. Linn was awarded a Presidential Citation from the American Psychological Association for her work on behalf of children.

Linn told the *Brookline Tab*, "Aside from love and friendship, what I value most is children and creativity." Although she would easily fit in several chapters of *Legendary Locals of Brookline*, her greatest impact is toward the social good—of her community and beyond. (Courtesy of Susan Linn.)

Mindy Lubber

Mindy Lubber is president and a founding board member of Ceres, a business-focused sustainability advocacy group. She also directs Ceres's Investor Network on Climate Risk, a group of institutional investors managing trillions of dollars in assets focused on the business risks and opportunities resulting from climate change. The United Nations named Lubber one of the "World's Top Leaders of Change." A Brookline resident, she also recently received the 2013 Public Health Leadership Award from the Friends of Brookline Public Health. Lubber started her advocacy work in 1995 as a senior policy adviser for the US Environmental Protection Agency, and was named administrator of the EPA's regional office in New England. During her time with the EPA, she organized massive cleanups of hazardous waste sites, encouraged redevelopment and urban revitalization, and ensured the protection of drinking water supplies. (Courtesy of Mindy Lubber.)

CHAPTER SIX

Science, Medicine, and Law

In a town that is surrounded by some of the top universities, law schools, and teaching and research hospitals in the nation, nay, the world, it's no surprise that there are so many Nobel Prize–winning scientists, pioneers of medicine, and distinguished lawyers who call Brookline home.

Researchers include Mark E. Josephson, an investigator into the diagnosis and treatment of heart rhythm disorders; Robert Weinberg, who discovered a gene that causes normal cells to form tumors and one that suppresses them; and Jeffrey Karp, who uses nanoscale/microscale materials and biology to help solve medical problems. These and others in this chapter are the extraordinary residents who help make Brookline such a desirable place to live and work.

In fact, there are so many Nobel Prize winners living or hailing from Brookline that they could form a second volume of this book! Game-changing doctors, scientists, and inventors not pictured in this chapter but definitely legendary include Dr. Zabdiel Boylston, who was born in Brookline. A physician during the 1721 smallpox epidemic in Boston, Boylston is credited with introducing an inoculation against the disease by using pustular material from a smallpox victim and injecting it into the arm of an individual testing negative for the disease. The inoculated patient showed mild symptoms of the affliction, but then recovered and was disease-resistant.

Other notable medical doctors and researchers include Dr. John Rock (1890–1984), a pioneer in human fertility. In 1944, he was the first researcher to fertilize a human egg in a test tube, and was among the first to freeze sperm cells and keep them viable for a year. But his most lasting legacy is his contribution—along with Dr. Gregory Pincus and Dr. M.C. Chang—to the development of the birth control pill. Joel Mark Noe (1943–1991) was a pioneering reconstructive plastic surgeon who specialized in the use of hand-held lasers to remove disfiguring birthmarks like port wine stains. He also founded one of the nation's first burn units. Dr. Franz C. Von Lichtenberg (1920–2012) was a world-renowned researcher in the fields of tropical medicine and infectious diseases—he edited *Pathology of Infectious Diseases*, the definitive textbook on the subject. Dr. Robert Goldwyn (1930–2010), a distinguished surgeon, journal editor, and plastic surgery authority, served as chief of plastic surgery at Beth Israel Hospital from 1972 to 1996 and was editor-in-chief of the medical journal *Plastic and Reconstructive Surgery* for 25 years. William Silen wrote in the *Harvard Gazette*, "Dr. Goldwyn was decorated by the governments of France, Germany, and Italy with their highest honors for his work. Yet he remained a humble man who treated patients with the same deference he would pay a national leader and with a wonderful charm and sense of humor."

Nobel Prize winners George Minot (1885–1950) and William Parry Murphy shared the 1934 Nobel Prize in Physiology or Medicine with George H. Whipple. Minot described the effective treatment of pernicious anemia by means of the liver. Murphy practiced medicine and researched diseases of the blood.

In the world of physics, Brookline boasts Sheldon Lee Glashow, a joint winner—along with classmate Steven Weinberg and Abdus Salam—of the 1979 Nobel Prize in Physics. The Swedish Royal Academy of Sciences chose Glashow and colleagues "for their contributions to the theory of the unified weak and electromagnetic interaction between elementary particles, including, inter alia, the prediction of the weak neutral current."

We also have Alan Guth, an award-winning theoretical physicist and cosmologist, and professor at MIT. Guth's research into elementary particle theory proposed that many features of our universe can be explained by the cosmological model of inflation.

Then there is Norman Ramsey (1915–2011), who was awarded one half of the 1989 Nobel Prize in Physics "for the invention of the separated oscillatory fields method and its use in the hydrogen maser and other atomic clocks," with the other half awarded jointly to Hans G. Dehmelt and Wolfgang Paul. In his Nobel Prize biography, Ramsey remarks, "My early interest in science was stimulated by reading an article on the quantum theory of the atom. But at that time I did not realize that physics could be a profession. At the time I graduated from Columbia in 1935, I discovered that physics was a possible profession and was the field that most excited my curiosity and interest." Ramsey taught and carried out research in his molecular beam laboratory at Harvard University for 40 years. He helped found the Brookhaven National Laboratory and Fermilab.

Being at the epicenter of so many teaching hospitals and medical programs means Brookline will continue to enjoy the spoils of medical progress for years to come. With close to 10,000 alumni as of 2011, Harvard Medical School's main campus is located just a few blocks north of the town line. Longwood Medical Area, which boasts Beth Israel Deaconess Medical Center, Boston Children's Hospital, Brigham and Women's Hospital, Dana Farber Cancer Institute and others, is also just a stone's throw away. Residents still wearing their green scrubs and walking home on Brookline Avenue are not an uncommon sight.

World-class doctors, lawyers, and scientists are attracted to Brookline's proximity to the city and their workplace, as well as its beautiful and spacious homes, where they can live peacefully and raise a family. The rest of us enjoy living in a community where there is such excellent health care and other services.

It's one of the reasons why many older Brookline residents forgo Florida and retire in place. The town's walkability, easy access to public transportation, proximity of services—including retail, civic, and social facilities—and its access to Boston-area cultural, medical, and educational facilities, makes it a popular town for seniors.

The liberal, intellectual atmosphere that typifies this town makes it a haven for the brainy among us. Everyone knows someone who graduated from Harvard or MIT. The site NerdWallet.com ranked Brookline No. 4 among the most educated places in America in 2014. There's no shame in being a nerd—after all, the nerds will one day discover a cure for Cancer or aging—perhaps both.

Dr. William Aspinwall (1743–1823)

Dr. William Aspinwall lived and worked for most of his life in Brookline. He attended Harvard University and studied medicine under Dr. Benjamin Gale. According to the 1949 proceedings of the Brookline Historical Society, Dr. Aspinwall was the first physician to settle in Brookline, though his work often took him miles outside of town, on horseback, with his medicines in the saddlebags. He established two hospitals to dispense smallpox inoculations, which attracted visitors from all over the area. As a child, he had lost the sight in one eye in a bow-and-arrow accident, but he was still able to fight (and proved a good shot) during the first battles of the Revolutionary War. It was after serving in the war that he famously quipped that he would rather save Yankees than kill the British! (Author's collection.)

Francis Channing Barlow (1834–1896)

Francis Channing Barlow was a lawyer and soldier who rose quickly through the military's ranks during the Civil War. Raised in Brookline, Barlow entered Harvard at 17 and graduated with honors. He was practicing law when the war broke out. Barlow quickly enlisted, deploying one day after being married to Arabella Wharton Griffith, a nurse. It was Arabella who would nurse him back to health many times—even when his injuries appeared lethal.

Richard F. Welch, quoting Col. Theodore Lyman in *America's Civil War*, described Barlow: "He looked like a highly independent-minded newsboy; he was attired in a flannel checked shirt; a threadbare pair of trousers, and an old blue kepi; from his waist hung a big cavalry saber; his features wore a familiar sarcastic smile . . . [yet] it would be hard to find a general officer to equal him." (Courtesy of the Library of Congress.)

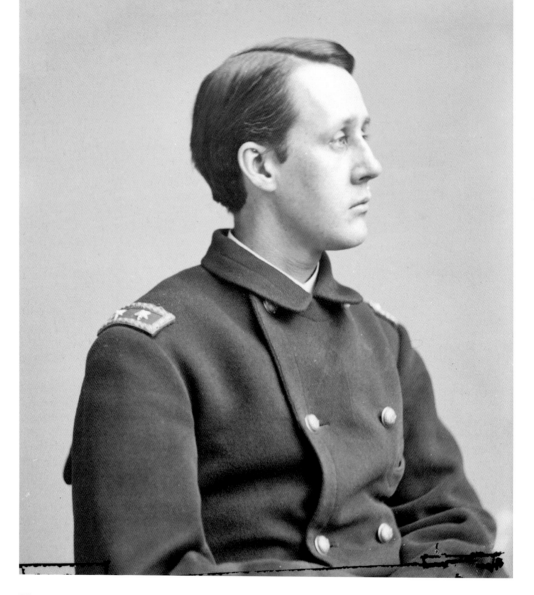

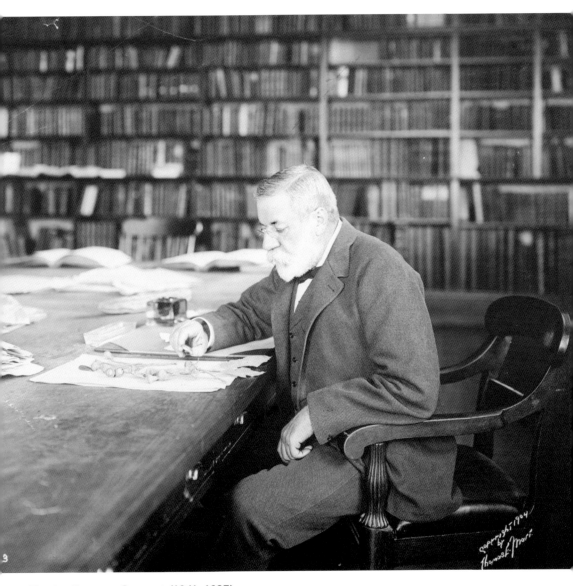

Charles Sprague Sargent (1841–1927)
Charles Sprague Sargent was fascinated by the natural world, particularly trees. Born into a wealthy, prominent family and raised on their Brookline estate, Sargent was drawn to estate horticulture. He graduated from Harvard University and served as an infantry officer during the Civil War, followed by an extended trip to Europe. But nothing inspired him quite like trees. In 1872, he was appointed curator and then director of Harvard's Arnold Arboretum. Apart from some time away helping the US Division of Forestry with a census investigation of forests, Sargent remained in charge of the arboretum until the month of his death in 1927. Sargent was married to Mary Ellen Robeson and had five children. His publications and work with the Arnold Arboretum brought the issue of forestry into the mainstream consciousness and helped shape the views of countless conservationists and legislators. (Courtesy of The Library of Congress.)

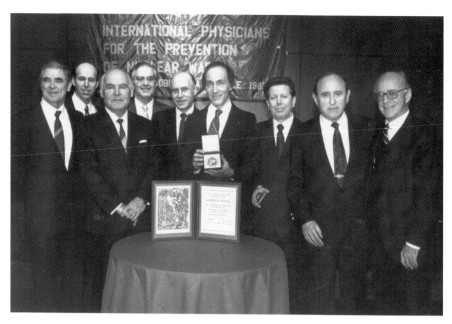

Eric Chivian

Dr. Eric Chivian is the founder of the Center for Health and the Global Environment and directs the Biodiversity and Human Health Program. In 1980, he cofounded International Physicians for the Prevention of Nuclear War, which was awarded the Nobel Peace Prize in 1985. He is the author of *Critical Condition: Human Health and the Environment* (1993). In 2013, Dr. Chivian retired from his position as assistant clinical professor of psychiatry at Harvard Medical School. A farewell message posted on Harvard School of Public Health's website stated, "Eric's drive to make the world a better place is always evident, even in the course of his daily conversations. We at the Center never cease to be amazed at the humility Eric shows even with all he has achieved." (Both, courtesy of Eric Chivian.)

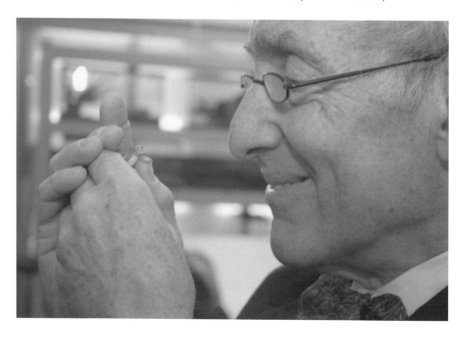

Mark E. Josephson
Mark E. Josephson is an internationally recognized investigator, clinician, and educator whose specialty is cardiac electrophysiology— the study of the electrical activity that stimulates the heart to beat and the diagnosis and treatment of heart rhythm disorders. He is the author of *Clinical Cardiac Electrophysiology: Technique and Interpretations*, a comprehensive textbook first published in 1979 and now in its fourth printing. He is the chief of cardiovascular medicine at Beth Israel Deaconess Medical Center in Boston, where he has worked since 1992. He is also the 2013 winner of the American Heart Association's prestigious Paul Dudley White Award, named for the founding father of the American Heart Association (AHA). In November 2013, he was awarded the Eugene Braunwald Mentorship Award at the national meetings of the AHA in Dallas. Josephson grew up in New York and now lives in Brookline with his wife. (Courtesy of Mark Josephson.)

Roger Lipson

Roger Lipson is a Brookline attorney. He started his career as a legal services attorney helping low-income clients. He later served as the director-counsel of the Brookline Rent Control Board. Lipson is the former president of the Brookline Chamber of Commerce and the Rotary, and is a founding member of the Brookline Legal Assistance Bureau. Recently, the Massachusetts Bar Association honored Lipson for 50 years of service. (Author's collection.)

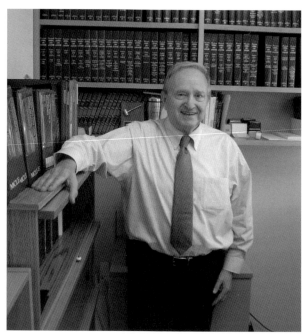

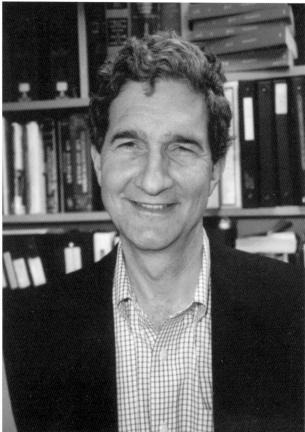

Cameron Kerry

Cameron Kerry, nicknamed "Cam," is perhaps best known as the younger brother of former Massachusetts senator and current secretary of state John Kerry. Part of the reason for this is Cam's willingness to work behind the scenes to support his brother's political career. The younger Kerry is the general counsel at the Department of Commerce and briefly filled an empty seat as secretary of commerce in 2013. (Photograph by Larry Ruttman.)

Jeffrey Karp
Jeff Karp is an associate professor at Harvard Medical School, Brigham and Women's Hospital. He is principal faculty at the Harvard Stem Cell Institute. His research uses materials and biology to solve medical problems with emphasis on nanoscale/microscale materials and bio-inspired biology. He has published more than 80 peer-reviewed papers and book chapters, has given over 100 national and international invited lectures, and has 50 issued or pending patents. (Courtesy of Jeff Karp.)

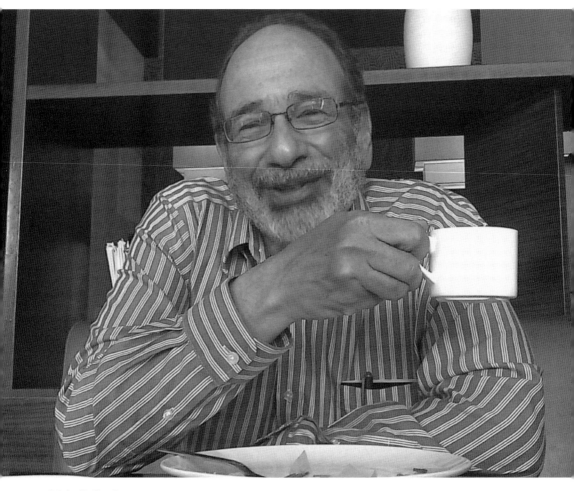

Alvin E. Roth
Alvin E. Roth shared the 2012 Nobel Memorial Prize in Economics with Lloyd S. Shapley, who, starting in the 1960s, used Cooperative Game Theory to study different ways to match different players in the best possible way. Roth used Shapley's theory to explain how markets function in practice. Roth redesigned the National Resident Matching Program, matching 20,000 new doctors with their first residencies at American hospitals. He also helped design the matching of students with public schools in New York and Boston and is one of the founders and designers of the New England Program for Kidney Exchange, which matches one willing but incompatible donor pair with another to achieve two healthy kidney donations. He is the Craig and Susan McCaw Professor of Economics at Stanford University and the Gund Professor of Economics and Business Administration Emeritus at Harvard University. (Courtesy of Eric Chang.)

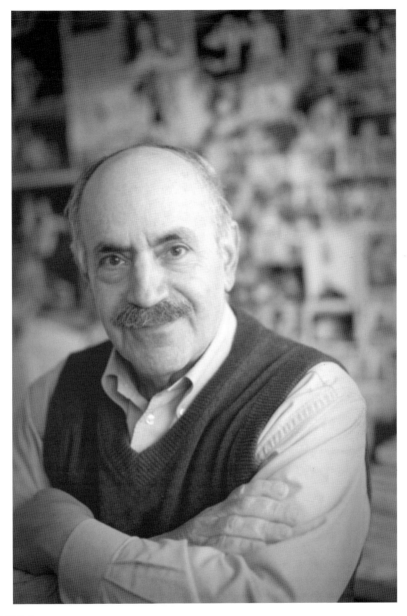

Robert Weinberg

Robert Weinberg is a founding member of the Whitehead Institute for Biomedical Research and a professor of biology at the Massachusetts Institute of Technology. The Weinberg lab is known for its discoveries of the first human oncogene—the ras oncogene that causes normal cells to form tumors—and the isolation of the first known tumor suppressor gene, the Rb gene. Research in Weinberg's laboratory is focused on the molecular mechanisms that control carcinoma progression and metastasis. His research is concentrated in understanding the collaborative impact of paracrine and systemic signaling on tumor growth and progression, identification of mechanisms through which paracrine and systemic signals can induce epithelial cells to enter into a mesenchymal/stem-cell state, and elucidating the complex molecular mechanisms that regulate carcinoma invasion and metastasis. (Courtesy of MIT.)

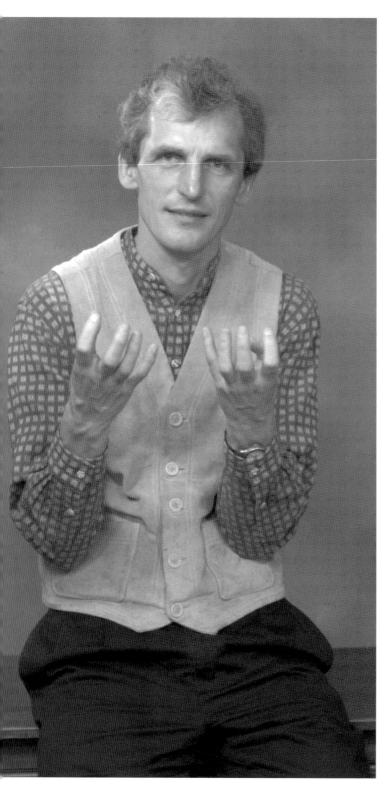

Wolfgang Ketterle
Wolfgang Ketterle shared the 2001 Nobel Prize in Physics with Eric A. Cornell and Carl E. Wieman. They won "for the achievement of Bose-Einstein condensation in dilute gases of alkali atoms, and for early fundamental studies of the properties of the condensates." Dr. Ketterle is the John D. MacArthur Professor of Physics, the associate director of Research Laboratory of Electronics, and the director of MIT-Harvard Center for Ultracold Atoms. According to the website for MIT's Department of Physics, Professor Ketterle's research is in atomic physics and laser spectroscopy, particularly in the area of laser cooling and trapping of neutral atoms with the goal of exploring new aspects of ultracold atomic matter. Since the discovery of gaseous Bose-Einstein condensation, large samples of ultracold atoms at nanokelvin temperatures are available. His research group uses such samples for various directions of research. (Courtesy of MIT.)

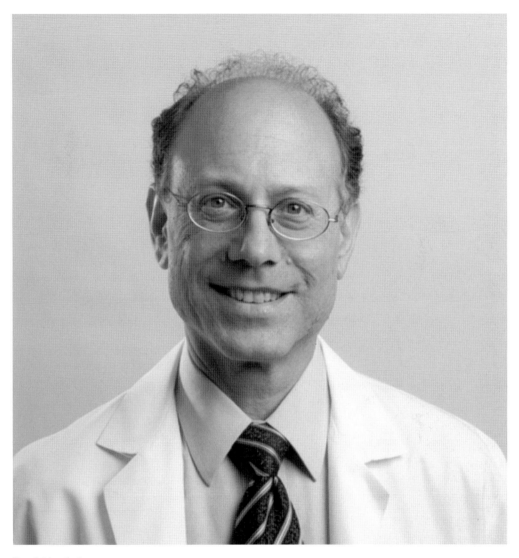

David Ludwig

David Ludwig was sounding the alarm over childhood obesity long before First Lady Michelle Obama made it her crusade. Dr. Ludwig, the director of medicine at Boston's Children's Hospital, professor in the Department of Pediatrics of Harvard Medical School, and professor of nutrition at Harvard School of Public Health, has been researching for years how diet, hormones, metabolism, and weight affect disease risk. He is particularly interested in the glycemic index/load and is responsible for creating the "low glycemic" diet plan that helps decrease the surge of blood sugar in the body after eating a meal. He is the founding director of the Optimal Weight For Life program, the country's largest multidisciplinary clinic to treat obesity in children. He is also the author of *Ending the Food Fight: Guide Your Child to a Healthy Weight in a Fast Food/Fake Food World*. (Courtesy of David Ludwig.)

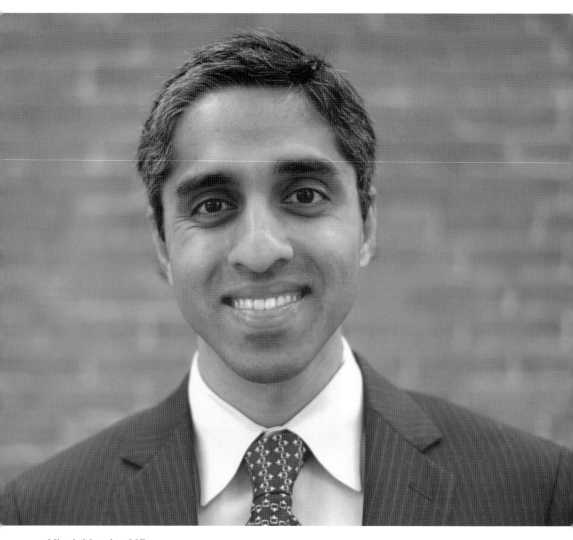

Vivek Murthy, MD
In 2013, President Obama nominated Brookline resident Vivek Murthy to become the 19th US surgeon general. Murthy has a bachelor's of arts from Harvard University and a doctorate of medicine and master's of business administration from Yale. He is a Brigham and Women's Hospital physician; an instructor at Harvard Medical School; founder and chairman of TrialNetworks, a software start-up helping drug developers collect information from clinical trials; and founder of VISIONS Worldwide, a nonprofit promoting education about AIDS and HIV. He is also the cofounder of Doctors for America, an organization of physicians who have been key supporters of the Affordable Care Act. As of this writing, Murthy's nomination has not been confirmed—debate over his moderate views on gun control have NRA members preparing to block his nomination. If confirmed, Murthy plans to focus on "obesity, tobacco-related disease, mental illness, and community-driven public health initiatives." (Courtesy of TrialNetworks.)

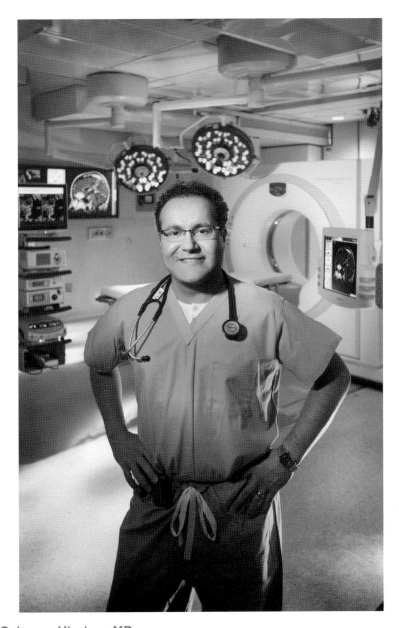

Alfredo Quinones-Hinojosa, MD
Dr. Alfredo Quinones-Hinojosa, or "Dr. Q," is an internationally renowned neurosurgeon and neuroscientist at Johns Hopkins Medical Center. Born in Mexicali, Mexico, he jumped the border at age 19, fleeing to Fresno, California, where he worked as a cotton picker, a painter, and a welder. He was accepted to the University of California, Berkeley, where he studied psychology. He then attended Harvard Medical School. The illegal alien who came to the United States with no money or command of English became a Harvard graduate. Many changes occurred in his life while attending Harvard; he moved to Brookline Village, got married, had a daughter, and became a US citizen. In 2005 he went to Johns Hopkins, where he is currently researching a cure for brain cancer. His story is documented in his autobiography, *Becoming Dr. Q: My Journey From Migrant Farmer to Brain Surgeon.* (Courtesy of Alfredo Quinones-Hinojosa.)

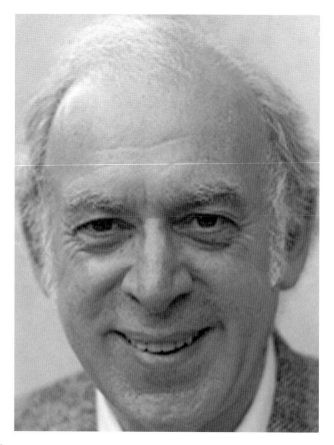

Jerome I. Friedman

Jerome Isaac Friedman is one of the winners of the 1990 Nobel Prize for Physics. The Royal Swedish Academy of Sciences awarded the prize to Friedman and colleagues "for their pioneering investigations concerning deep inelastic scattering of electrons on protons and bound neutrons, which have been of essential importance for the development of the quark model in particle physics." Friedman is Institute Professor and Professor of Physics Emeritus at MIT.

In a biographical essay he wrote about himself for the Nobel Prize website, Friedman recalled his formative experiences as a budding physicist in high school and college:

> I sought admission to the University of Chicago because of its excellent reputation and because Enrico Fermi taught there. I entered the Physics Department in 1950, receiving a Master's degree in 1953 and a Ph.D. in 1956. It is difficult to convey the sense of excitement that pervaded the Department at that time. Fermi's brilliance, his stimulating, crystal clear lectures that he gave in numerous seminars and courses, the outstanding faculty in the Department, the many notable physicists who frequently came to visit Fermi, and the pioneering investigations of pion proton scattering at the newly constructed cyclotron all combined to create an especially lively atmosphere. I was indeed fortunate to have seen the practice of physics carried out at its "very best" at such an early stage in my development. I also had the great privilege of being supervised by Fermi, and I can remember being overwhelmed with a sense of my good fortune to have been given the opportunity to work for this great man. It was a remarkably stimulating experience that shaped the way I think about physics.

(Courtesy of MIT Physics.)

CHAPTER SEVEN

Visual Arts

Brookline is a town that cares about its artists. After all, a place made up of so many left-brained thinkers—all those scientists, doctors, lawyers, and business professionals—appreciates an artist's ability to bring beauty, joy, and emotional release to the fore.

As a town that supports the arts in all of its forms, there is no shortage of innovative and classic visual artists and programs to nurture their talents. The Brookline Arts Center at 86 Monmouth Street was founded in 1964 and offers art instruction to the community through classes taught by professional working artists. The Brookline Arts Center also showcases different local, regional, and national artists monthly. It hosts gallery talks, symposia, and other educational programs "where art lovers can meet and discuss art with professionals." 2014 marked the 50th Anniversary of the BAC.

Artists looking for funding to produce, publish, display, or perform their work can apply for grants from the Brookline Commission for the Arts. The BCA offers yearly grants to Brookline-based artists and arts-related organizations with funds from the Massachusetts Cultural Council. Grants are given to literature, music, theater, and the graphic and plastic arts. Past winners include the Brookline Teen Center's painted mural project with artist Ben Jundanian; Landmarks of Brookline by Wendy Soneson; Genki Spark, a spring celebration of dance and culture at Brookline High School; and Studios Without Walls' "Through the Trees" installation.

One of the best ways to see the depth, variety, and talent of Brookline's artistic community is to attend the town's annual Open Studio tour. Organized by artists Peg O'Connell and Gwen Ossenfort, this spring event is arguably the most exciting for local artists and art lovers alike. Some Brookline artists gather at local venues like the public library and the police department to show their work, while others open their living rooms and garages to the artsy and the merely curious. Brookline Open Studios started in 1986 and was originally held every other year. Its surging popularity inspired organizers in the late 1990s to make it an annual event.

"Access is the most important part of Open Studios," Gwen Ossenfort told Brookline Hub.com. "The public can see what a working studio looks like, see how the artists work, talk to them, ask them questions. The artist in turn gets access to public feedback. Some people will come in, look, and leave, but others will stay and talk to the artist for an hour about their composition." For some artists, she added, Open Studios also means the validation of selling their work.

There is also the juried Coolidge Corner Arts Festival, held every year in June on the grounds of the Devotion School. A mixture of both art and craft vendors, the annual fair attracts thousands of people interested in browsing or bringing home a one-of-a-kind handmade treasure. 2014 marked the 36th year of this very popular festival.

Tying the Open Studios and the Coolidge Corner Arts Festival together is ArtsBrookline, a group conceived by the longtime organizer of the Arts Festival, Lea Cohen, with the help of Peg O'Connell of Open Studios. The group formed in 2013 to offer a showcase of arts events and a resource for Brookline residents (and anyone interested in the arts) to "find everything from literary arts to exhibits to dance and musical performances."

Some of the legendary locals in this chapter include Isabella Stewart Gardner, the art collector and museum namesake who spent time in Brookline at her husband's estate, Green Hill; Frederick Law

Olmsted, the landscape architect and subject of the Frederick Law Olmsted National Historic Site at 99 Warren Street; Rania Matar, a Lebanese photographer whose work was recently on display at the Museum of Fine Art; and Muriel Cooper, a much-admired graphic designer responsible for, among other things, creating the MIT Press's iconic colophon.

A few artists not pictured in the book but who made significant contributions to visual art in Brookline and beyond include Samuel Colman (1832–1920), an artist and landscape painter and one of the leading names in the second wave of the Hudson River School. His father was a bookseller and dealer in engravings and Colman was exposed early to the arts. According to *Brookline: The History of a Favored Town* (1837), Colman and his family lived for a few years on Walnut Street and young Colman attended Brookline High School. The family then moved to New York, where Colman studied under Asher B. Durand, an American painter of the Hudson River School. Colman was one of the first artists to receive critical acclaim for his use of watercolors. He organized the American Society of Painters in Water Colors, and served as the organization's first president. He was also a founding member of the New York Etching Club and the Boston Society of Etchers.

Brookline High School alum and artist Edna Hibel is an internationally recognized artist and colorist. Hibel creates lithographs on porcelain. She started painting at age nine studying watercolor painting, and later attended the Boston Museum School of Fine Arts. She began working on her lithographs in 1966, using stone, paper, silk, wood, veneer, and porcelain. In 1995, Hibel was commissioned by the Foundation of the U.S. National Archives to create a work commemorating 75 years of women's right to vote.

Abelardo Morell is a photographer who practices a technique called camera obscura. His work has been collected and shown at the Museum of Modern Art, the Whitney Museum, the Chicago Art Institute, and many others. Born in Havana, Cuba, Morell and his family fled the communist country in 1962. He lives in Brookline and is professor emeritus in the Photography Department at Massachusetts College of Art and Design.

If you're looking for modern sculpture with the feel of Christo and Jeanne-Claude, Brookline collaborative Studios Without Walls is a good bet. The sculptors of Studios Without Walls create temporary outdoor art that "stimulates dialogue about aesthetics, environment, and community." The group's most recent exhibit, Out in the Open, was hosted in Riverway Park at the Longwood T station.

Isabella Stewart Gardner (1840–1924)

Isabella Stewart Gardner was born in New York City. Her father, David Stewart, made his fortune in linen cloth and iron, a fortune he would later leave to his daughter upon his death in 1891. Isabella went to private schools in New York and Paris, getting a taste for travel at a young age. One particular trip to Milan, Italy, with her parents would have a deep impact on the future art collector.

A classmate in Paris introduced Isabella to her brother, Jack Gardner. Isabella later married Jack, and they moved to Gardner's hometown of Boston. In 1863, they had their first child, but he died two years later and after a miscarriage, Isabella was warned not to get pregnant again. This news naturally upset her, and she fell into a depression. Jack Gardner arranged for a trip to Europe to help restore his wife's *bonne humeur*. It worked. Isabella Gardner developed a passion for art collecting. She even dreamed of opening her own museum, one that was as inviting as stepping into someone's private home.

Isabella Stewart Gardner eventually built that museum. After her husband's death in 1898, Isabella commissioned the construction of Fenway Court. She oversaw every detail of the construction and design. It was built in the Venetian style she had seen and admired during her trips to Italy. She moved into the fourth floor of the new building; she would live there until her death in 1924. The museum opened to the public in February 1903 and was a hit.

In 1990, a brazen art heist occurred that would be reported around the world. Robbers dressed as police officers stole some of the museum's most valuable works, including three Rembrandts and a Vermeer. The art was never recovered. Due to a stipulation in Isabella Stewart Gardner's will that nothing in the permanent collection could be changed, museum officials left blank spots on the wall where the stolen art had hung.

Isabella Stewart Gardner's connection to Brookline is her husband's inherited estate, Green Hill, a farmhouse on 285 Warren Street. Isabella designed gardens and a new conservatory on the property and lived there briefly. (Courtesy of the Library of Congress.)

Henry Hobson Richardson (1838–1886)
Henry Hobson Richardson was born in Louisiana on the Priestley Plantation. He moved to the Northeast to attend Harvard University in 1855. While at Harvard, he decided to pursue a career in architecture. He studied at the École des Beaux-Arts in Paris and worked in the office of French architect Theodore Labrouste before returning to the United States. His first commission came in 1866, when he designed the Church of the Unity in Springfield, Massachusetts. After marrying Julia Gorham Hayden of Boston, the couple moved to a house on Staten Island, New York. He worked in New York City for eight years, designing an insane asylum in Buffalo and Brattle Square and Trinity Churches in Boston, among other projects. His work on the Trinity Church brought him much acclaim and so many Boston-based commissions that he moved his family back to Massachusetts. He built a house in Brookline where he also installed his office and studio. (Courtesy of the Library of Congress.)

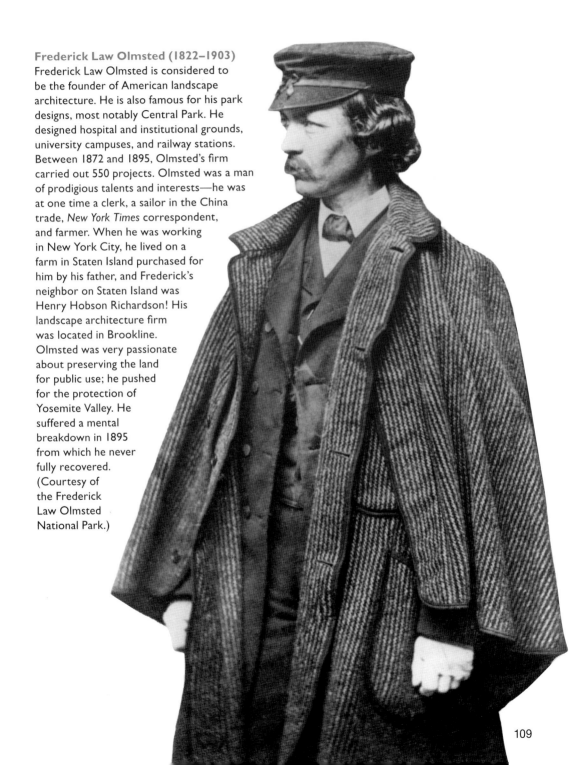

Frederick Law Olmsted (1822–1903)
Frederick Law Olmsted is considered to be the founder of American landscape architecture. He is also famous for his park designs, most notably Central Park. He designed hospital and institutional grounds, university campuses, and railway stations. Between 1872 and 1895, Olmsted's firm carried out 550 projects. Olmsted was a man of prodigious talents and interests—he was at one time a clerk, a sailor in the China trade, *New York Times* correspondent, and farmer. When he was working in New York City, he lived on a farm in Staten Island purchased for him by his father, and Frederick's neighbor on Staten Island was Henry Hobson Richardson! His landscape architecture firm was located in Brookline. Olmsted was very passionate about preserving the land for public use; he pushed for the protection of Yosemite Valley. He suffered a mental breakdown in 1895 from which he never fully recovered. (Courtesy of the Frederick Law Olmsted National Park.)

Yanick Lapuh

Yanick Lapuh was born in Mont Saint Martin, France. He is known for his abstract sculptural paintings using wood cutouts at different angles on a base. Lapuh attended the Massachusetts College of Art and the school of the Museum of Fine Arts in Boston. As a young artist he studied sculpture, but soon, his focus turned to drawing and painting. With time, he saw that texture and form were dominant forces in his work, and slowly, sculpture began to reemerge in the form of three-dimensional forms. He built out his canvases, showcasing the contrast between flat and multidimensional. In this way, his paintings actually blur the line between painting and sculpture.

On his website, Lapuh states, "In all my work I seek to create and re-create my own vocabulary to express my vision." (Both, courtesy of Yanik Lapuh.)

Jill Medvedow

Jill Medvedow is the director of Boston's Institute of Contemporary Art (ICA), where she has presided since 1998. She was responsible for managing the herculean effort to move the ICA from its stodgy digs in the Back Bay to its current home on the waterfront. Often called "the Jewel of the Waterfront," the new ICA is a feat of architecture, and its new location not only increased the number of visitors and members, but also created a beacon around which other new businesses prospered. The "crazy optimist" defied Bostonians who said she could not raise over $50 million to fund the move by raising $15 million more than that. (Courtesy of Asia Kepka.)

Alejandro Siña and Moira Siña

Alejandro and Moira Siña are light artists and the founders of Siña Lightworks, based in Brookline for over 30 years. They are known throughout the world for their luminous installations, sculptures, and mobiles that they create using gas, glass, and nearly invisible wiring. The Siñas' "The End of the Red Line"— 1,000 neon art tubes suspended from the ceiling—is a permanent installation at the Alewife T station. Alejandro is from Chile and was a fellow at the Center for Advanced Visual Studies at Massachusetts Institute of Technology. While at MIT, he pioneered the use of high-frequency electronics and luminous gas phenomena to create ethereal art. Moira Siña has a background in architecture and design. The couple frequently participates in annual Brookline events like the First Light Festival and Open Studios. (Courtesy of Alejandro Siña.)

Rania Matar

Born and raised in Lebanon, Brookline resident Rania Matar is a photographer and teacher. Matar's primary subjects are girls and women. A collection of her photographs, *A Girl and Her Room*, was part of the 2013–2014 exhibition *She Who Tells a Story* at the Museum of Fine Arts in Boston. In the series, various teenaged girls sit, recline, and slouch in chairs, on beds, and against walls in their bedroom. Writer Susan Minot describes the relationship between Matar and her subjects in *Girl and Her Room*, "The girls in these photographs willingly opened their doors to an outsider, trusted her, shared their intimacy with her and exposed themselves and their vulnerability." Matar teaches photography at the Massachusetts College of Art and Design. She has released two printed photography collections: *Ordinary Lives* (2009) and *A Girl and Her Room* (2012). (Courtesy of Rania Matar; inset, photograph by and courtesy of Rania Matar.)

Laura "Lola" Baltzell

Laura "Lola" Baltzell is an encaustic artist. Encaustic is a technique that uses heat to burn and melt beeswax onto paper to create a painting on wood, stone, or plaster. She also incorporates various found objects into her art. For her 50th birthday, Baltzell asked her friends to give her "rusty pieces from their garage" through which she eagerly sorted for materials. Baltzell, who was recently appointed exhibitions director of the International Encaustic Artists Organization, curated the War and Peace Project, a collection of 747 individual five-by-seven-inch collages, each incorporating one page of Leo Tolstoy's *War and Peace*. It was a project that took two years and a team of five to complete. She undertook it after being diagnosed with metastatic breast cancer in 2008. Now cancer-free, Baltzell called the project "life-affirming, life-changing, and indeed life-saving." (Courtesy of Mark Natale.)

Theo Alice Ruggles Kitson (1871–1932)
Theo Alice Ruggles Kitson was a sculptor born in Brookline who specialized in war monuments. Her two most famous works include "The Hiker," a statue commemorating the soldiers who fought in the Spanish-American War, the Philippine American War, and the Boxer Rebellion; and a monument to Polish freedom fighter Thaddeus Kosciuszko that can be found in Boston's Public Garden (pictured here). Theo exhibited artistic talent at an early age, but she was turned away from the School of the Museum of Fine Arts because at the time it did not accept female students. Instead, she studied with English sculptor Henry Hudson Kitson, whom she married in 1893. Theo was the first woman to be inducted into the National Sculpture Society, in 1895. In 1904, she earned a bronze medal at the St. Louis World's Fair. (Author's collection.)

Cristina Powell

Cristina Powell is an artist and a volunteer with A Brighter Way, a nonprofit named after one of her paintings. Powell was born in Peru and immediately adopted. When she was 15 months old, she was diagnosed with cerebral palsy and was not expected to walk or talk—although she went on to defy these odds. Encouraging words from her sixth-grade teacher about one of her paintings inspired Powell to focus on making art. When she discovered that her pictures of flowers and bright, primary colors made people feel good, she started to reach out to people through hospital visits and through her paintings. Powell said, "My mom and I like to say . . . our lives are like a garden . . . always changing and challenging, but full of color, love, and happiness." (Courtesy of Leanne Powell, Painting by Cristina Powell.)

Paul Szep

Paul Szep is a political cartoonist. He was the chief editorial cartoonist at the *Boston Globe* from 1967 to 2001. A two-time Pulitzer Prize winner, Szep remarked, "I am a very political individual and I think this is reflected in my work. Some people . . . do gag cartoons, but I always try to do cartoons that make a political comment." Art Buchwald has said of Szep, "Some lawmakers and establishment figures refer to Paul Szep as the 'Boston strangler' and others are less gracious." Today, Szep's work can be found on the Huffington Post's "The Daily Szep" and is syndicated by the Creator's Syndicate. Szep recently looked back and said, "Living in Brookline was simply the best: great schools for my kids, wonderful restaurants and public facilities, and stimulating neighbors and friends." (Courtesy of Paul Szep.)

Reed Kay

Reed Kay is a painter often associated with the Boston Expressionists. After serving as a corporal with the Army Corps of Engineers and being wounded by mortar shrapnel, he was offered the chance to study at the prestigious Ecole des Beaux-Arts in Paris, a school that counts Degas, Renoir, Millet, and Cassatt among its alumni. He taught for 34 years at Boston University's School of Visual Arts and has been married for 67 years to his wife, Frieda. In an interview with the *Metrowest Daily News*, he said, "I always wanted to put on canvas the same emotional effect I felt looking at that particular scene. I'm not interested in recording every little detail. I'm interested in the push of a street or how a bridge arches over a river. I'd ask myself 'what's visually impressive about the scene?' Then I'd work on it until it resonated." (Courtesy of Ben Aronson.)

Elaine Koretsky
Elaine Koretsky is the director of the Research Institute of Paper History and Technology and the International Paper Museum at 8 Evans Road in Brookline. She has written seven books and produced 25 documentary films on the subject of paper history with the help of her husband, physician, teacher of medical students, and researcher of angina pectoris Sidney Koretsky, now retired. According to the *Brookline Tab*, Koretsky's interest in paper was sparked after an attempt to make paper out of salvaged shavings from a woodworking project. She graduated from Brookline High School and Cornell University, where she was elected Phi Beta Kappa. She and Sidney Koretsky have lived in Brookline for over 55 years, and in 2013 they celebrated their 60th wedding anniversary. (Courtesy of Sidney Koretsky.)

Ruth Ginsberg-Place
Brookline resident Ruth Ginsberg-Place is a photographer, printmaker, and book artist. Born in New York, Ginsberg-Place received her master's of fine arts from Syracuse University and then joined the art faculty at Southern Illinois University. Since 1973, her studio has been at the Boston Center for the Arts. Her books use photographs and prints with imagery of landscapes or trees. Ginsberg-Place explains her work: "My photographs and prints are semiabstract but nature based, and I work in pairs or suites. Each individual artwork becomes richer in relation to its partner image or images. Playing with sets allows me to explore many facets of an idea." (Courtesy of Ruth Ginsberg-Place.)

Murray Dewart
Murray Dewart has been a sculptor for 40 years. Self-taught, Dewart started with woodcarving. He always maintained a day job—but then his work started selling. His bronze and granite pieces are often found in gardens, where their Asian sensibility complements the surroundings. Dewart's public works have graced the Boston Common, Harvard University, Dexter School, Franklin Street Park, and the International Sculpture Park in Beijing. Born in Vermont, Dewart says of his art, "I wish to make sculpture look at home in the natural world of gardens and in parks. Call it my quest for harmony, of both the inner and outer kind." (Photograph by James Arzante, MD.)

Katrina Majkut

Katrina Majkut is a research-based artist whose work includes a cross-stitch of a birth control blister pack and a series of paintings about the often-strange rituals of modern weddings, like the cult of the engagement ring and the cringe-worthy bachelorette party. Majkut told *Boston* magazine, "I wanted to understand . . . why are we going through the motions if we know that, outside of a wedding, this is not necessarily aligned with our modern lifestyles?" She is the creator of the website TheFeministBride, whose mission is to "be a voice for independent women who seek to modernize marriage, promote equality, break down double standards, and to walk down the aisle to their own tune." (Photograph by Theodore Majkut.)

Artists of Gateway Arts

Gateway Arts offers services and career opportunities for people with psychiatric disabilities, and visual, hearing, and other impairments. First established in 1973 by the Developmental Disabilities Unit of the Massachusetts Mental Health Center, Gateway Arts was part of the state's deinstitutionalization of people with disabilities into community-led day programs. Gateway Crafts, as it was then called, was located in a small basement studio in Allston. Renamed Gateway Arts in 2001, the program has expanded over 40 years, moving to Brookline Village and opening an onsite "Outsider Art" gallery—the first of its kind in Boston—in 1995. Gateway Arts is one of only 20 comprehensive art centers for individuals with disabilities worldwide. The artists of Gateway have had their work shown in the window at Barney's, at Chestnut Hill Mall, the Fuller Museum of Art, and elsewhere. (Courtesy of Gateway Arts.)

Cecile Raynor

Cecile Raynor's specialty is kinesthetic artwork. Using ink and pastels, Raynor does blind drawings of dancers and musicians that end up in shadow boxes. She likes to capture movement and emotion. She is a former dancer and a teacher of the Alexander technique, as well as a Thai yoga therapist—all of which inform her art. The paper on which she draws is thick, and the edges are ripped around the figures. Combined with the many layers of colors, it creates texture and depth. Describing her blind process, Raynor says, "I may peek at my drawing if it is a complex one but I stop drawing while I peek. Also, I sometimes add a few details afterward when necessary like a line here, a dot there. Only then do I choose those drawings that lend themselves to adding pastel color." (Courtesy of Cecile Raynor.)

Martin Anderson

Martin Anderson is a photographer. His interest in photography started taking off when he was a teenager and one of his first photographs, printed in a home darkroom, won an art association prize. After spending years as an actor, director, and teacher, Anderson has returned to his first love, photography. He is as interested in the equipment he uses to create his art as he is in the art itself. As Anderson says, "for the last few years my photography has become more and more centered on the alternative processes of making pictures." In addition to using traditional cameras, the Brookline artist uses low-tech plastic lens cameras and has over 30 self-constructed pinhole cameras made from tin cans and cardboard tubes. (Courtesy of Martin Anderson, work by the artist and courtesy of Martin Anderson.)

Muriel Cooper (1925–1994)

Muriel Cooper was a graphic designer and educator. She was a professor of interactive media design in media arts and sciences at MIT's School of Architecture and cofounded and directed MIT's Visible Language workshop at Media Lab. Cooper first came to MIT in 1952 as director of the publications Office (now Design Services). She left the school on a Fulbright scholarship to Milan and then returned to Boston and opened her own graphic design studio, counting MIT Press as one of her clients. She designed the unmistakable colophon for MIT Press—it represented an abstraction of the letters "MITP"—and later, in 1967, she joined the press as its first art director. At the time of her death, Cooper was the only female tenured professor at the MIT Media Lab. She died suddenly of a heart attack at age 68. (Courtesy of MIT Media Lab.)

INDEX

Adams, Isaac, 67
Anderson, Larz, 68
Anderson Weld, Isabel, 65, 68
Anderson, Martin, 125
Andrews Kent, Louise, 34
Gateway Arts, 123
Aspinwall, William, 65, 91
Atherton, Ray, 72
Audy, Elias, 14
Baker Miller, Jean, 74
Baltzell, Laura "Lola," 113
Barlow, Francis Channing, 92
Barnes, Linda, 31, 35
Barrett, Seth, 8, 20
Bellow, Saul, 31
Berger, Fran, 18
Bezahler, Ilene, 13
Blake, Ran, 52, 54
Bravman, R. Harvey, 10, 20
Brigham, Dana, 9, 12, 32
Burgin, Richard, 44
Burstein, Michael A., 43
Cavell, Stanley, 45
Cheung, Vienne, 17
Childers, Rachel, 52, 55
Chivian, Eric, 94
Conquest, Ida, 25
Cooper, Muriel R., 126
Corrigan, Jack, 79
Devotion, Edward, 67
Dewart, Murray, 121
Dickson, Harry Ellis, 52, 53, 77
Dunn, Florence, 51, 62
Dukakis, Katharine "Kitty," 77
Dukakis, Michael S., 53, 65, 77, 79
Eppstein, David, 75
Epstein, Paul, 73
Epstein, Theo, 73
Eskin, Hank, 29
Ferry, David, 31, 38
Friedman, Jerome I., 104
Gabridge, Patrick, 28
Gillette, King, 11
Ginsberg-Place, Ruth, 120
Gladstone, Sarah, 8, 81
Golijov, Osvaldo, 56

Goodman, Ellen, 32, 48
Grossman, Hildy, 25
Hayes, Roland, 51–52
Hill Simpson, Johanna, 51, 58
Hobson Richardson, Henry, 108, 109
Hodgman, John, 27
Hoy, Chobee, 9, 19
Hurley Jr., Arthur J., 76
Josephson, Mark E., 89, 95
Karp, Jeffrey, 89, 97
Kaplan, Sumner, 82
Kay, Reed, 118
Kennedy, John F., 8, 23, 65, 70, 71
Kennedy, Joseph P., 65, 70, 72
Kennedy, Robert F., 71
Kerry, Cameron, 96
Ketterle, Wolfgang, 100
Koretsky, Elaine, 119
Krakauer, Jon, 41
Kuchi, Aveline, 84
Kuchi, Michio, 84
LaCount, Shawn, 26
Lapuh, Yanick, 110
LaPlante, Eve, 32, 36
Lefton, Lester, 82
Lehane, Dennis, 31, 40
Libman, Mai Le, 9, 15
Lipson, Roger, 14, 96
Lowe, Rosaline, 9, 15
Lowell, Amy, 31, 33
Lubber, Mindy S., 88
Ludwig, David, 101
Majkut, Katrina, 122
Matar, Rania, 105, 113
McMurray, Joseph, 83
Medvedow, Jill, 111
Miller, Roger Clark, 63
Morell, Abelardo, 106
Morey, Katherine A., 69
Murphy, Evelyn, 78
Murthy, Vivek, 102
O'Leary, Daniel C., 83
Olmsted, Frederick Law, 105, 109
Powell, Cristina, 116
Quinn, Susan, 47
Quinones-Hinojosa, Alfredo, 103

Raynor, Cecile, 124
Reddi, Rishi, 39
Rochinski, Steve, 61
Roth, Alvin E., 98
Rothstein, Steven, 86
Ruggles Kitson, Theo Alice, 115
Ruttman, Larry, 32, 45, 79, 83
Schmahmann, David, 49
Senator, Susan, 31, 46
Shapiro, Alan, 42
Shire, Lydia, 18
Siña, Alejandro, 8, 112
Siña, Moira, 8, 111
Siraj, Amir, 59, 60
Siraj, Layla, 59, 60
Siraj, Yasmin, 59, 60
Smith, Marshall, 12
Smith, Sarah, 32, 35
Soifer, Barbara Yona, 21
Solomon, Jim, 8, 9, 16
Sprague Sargent, Charles, 93
Stanley, Ashley, 66, 81
Steinbergh, Judith, 43
Stern Strom, Margot, 75
Stewart Gardner, Isabella, 105, 107
Szep, Paul, 117
Tappan, Lewis, 11
Taylor, James, 64
Walcott, Derek, 31, 37
Walker, Liz, 24
Weinberg, Robert, 89, 99
Weiss, Ethel, 8, 10, 22
Weld, William, 65
Welker, Peter, 57
Welsh, Mikey, 61
Winiker, Bo, 57
Wolf, Gary K., 31, 50
Zina, Joe, 30